IMAGES
of America

ASSYRIANS IN
CHICAGO

Cover Image: This is a photograph of the first Assyrians to arrive in America from Urmia. They came to Chicago in 1903.

IMAGES
of America

ASSYRIANS IN CHICAGO

Vasili Shoumanov

ARCADIA

Copyright © 2001 by Vasili Shoumanov.
ISBN 0-7385-1908-1

Published by Arcadia Publishing,
an imprint of Tempus Publishing, Inc.
3047 N. Lincoln Ave., Suite 410
Chicago, IL 60657

Printed in Great Britain.

Library of Congress Catalog Card Number Applied For.

For all general information contact Arcadia Publishing at:
Telephone 843-853-2070
Fax 843-853-0044
E-Mail sales@arcadiapublishing.com

For customer service and orders:
Toll-Free 1-888-313-2665

Visit us on the internet at http://www.arcadiapublishing.com

This book was prepared as "The Photo Archives—Project Save" at the Ashurbanipal Library of the Assyrian Universal Alliance Foundation.

CONTENTS

ACKNOWLEDGMENTS

When I lived in Russia, I published the Assyrian magazine, *Homeland*. In the third issue, we began a new theme called "Old Photo." It demonstrated aspects of the lives of Assyrians many years ago, before the Russian Revolution and after it—including family albums, history of the first organizations, famous people, and so on.

Long before we began to issue our magazine, my teacher, Professor of the Theological Seminary of St. Petersburg, Russia, Michael Sado, had his private archives. He collected Assyrian books, historical photos of organizations, biographies of individuals, and all kinds of other documents. He created the first Assyrian archives. It is still a private collection, but it is a very large one. He taught me how to collect and sort historical materials. That knowledge is still useful to me—thanks to him.

In 1995, I came to Chicago and met the Honorable Homer Ashurian, archaeologist and former leader of Iranian Assyrians, who was working at Assyrian Universal Alliance Foundation. He offered me a position at Ashurbanipal Library and Heritage Museum as a librarian and history researcher. He always helps me with valuable suggestions in my work, and I thank him.

Ashurbanipal Library has an excellent collection of rare books, periodicals, manuscripts, old photographs, and all kinds of history documents. People of Chicago know this library very well. They donate books, photos, and family archives. We thank them for their many contributions.

The library is known in scholar circles as an "oriental" library. We have many excellent contacts with Harvard College Library, Cambridge, Massachusetts, and the University of Chicago. They always help us, and we thank them.

Special thanks go to Elaine Thomopoulos, editor of *Greek-American Pioneer Women of Illinois*, who initiated me to prepare this publication.

I thank Arcadia Publishing, especially Christina Cottini, Acquisitions Editor of Arcadia, who gave me a chance to prepare this book. I felt it a privilege to have this opportunity to present this title in the *Images of America Series*. I am very happy to be able to give some contribution to the history of the Assyrian community of Chicago.

I would like to thank the following contributors, individuals, and organizations for donation of photographs, documents, and support provided in the preparation of this book: Assyrian Universal Alliance Foundation, Senator John Nimrod, Honorary Homer Ashurian, Lincoln S. Tamraz, Rose Alexander, Sari Georges, Laura Paz, Dr. Francis X. Paz, Madlyn Pera Foley, Daniel Wolk, Florence Sayad-Yacoub, Yosip Mnashi Enwiga, Yousip M. Gewargis, Helen

Oshana, Firas Jatou, Sarkis Samuel, Grase Nathan, Thomas, Jouce Mirza, Aram Shaul Youkhana, Isho Balou, Anoushi A. Alawerdy, Robert DeKelaita, Edison Hasso, Ethel Tamraz, Sadi Samuels, Fridoun Mirza, Sarah Alwerdy, Violet Saliby, Frederick Mirza, Fereidoun Es-Haq, Sargon Aboona, John J. Yonan, Samuel Fox, and Jack David.

INTRODUCTION

The modern Assyrians are of Semitic race and are descendants of ancient Babylonians, Assyrians, Syro-Arameans, and also of Persians and Jews. Their culture also absorbed in itself elements of ancient dead civilizations like the Sumerian.

Assyrians were one of the first peoples who accepted Christianity and became zealous spreaders of it, all over the world. In the Christian era, Assyrians did not have their state and were persecuted. For centuries, they were driven from one place to another and were finally forced to seek refuge in the mountains of Hakkary (Kurdistan). The tragic events of World War I forced them to abandon their historical land and move to Russia, America, and later to Europe. Today, there is probably no country where you would not be able to find Assyrians.

Several thousands of Assyrians now live in Chicago. The largest center of their Diaspora is Chicago. The history of Assyrians in Chicago is very interesting and rich. We can say with confidence that Assyrians have made their own contributions to the past development of Chicago, and they now play a part in the modern political and cultural life of the city.

For this book I have selected and assembled 200 photos and sorted it chronologically from the nineteenth to the twentieth centuries.

One

From Iran to the USA
The Early Days
of a New Community

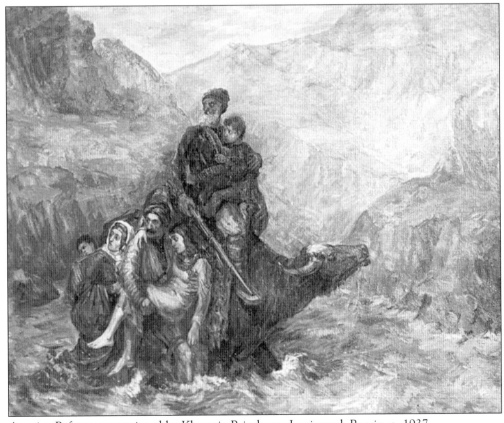

Assyrian Refugees was painted by Khnania Brindarov, Leningrad, Russia, *c*. 1937.

Long before Assyrians appeared in America, they had very strong contacts with the American Presbyterian Mission in Iran. The first immigrants came to America to obtain education in colleges and universities. They were sent by American missions, which functioned in Iran since 1833.

Dr. Justin Perkins and his medical assistant, Dr. Asahel Grant, were the pioneers of the American Mission among Assyrians in Persia. Dr. J. Perkins, along with his colleagues, organized classes in their mission for the instruction of English. American missionaries operated the printing press and spent years translating old Assyrian religious books into the modern language and published them (about 30 publications) at a new mission publishing press. In 1849, the Presbyterian Mission began to publish *The Rays of Light* periodical.

In 1836, Dr. Perkins organized the first mission school for the Assyrians in Urmia. Later it was reorganized into two separate institutions—Qalla College for boys and Fiske Seminary for girls.

In 1843, Dr. Perkins visited Mt. Holyoke College. He found Miss Fiske ready to be a teacher in Urmia. On June 14, 1843, she was in the field. Fedelia Fiske was a founder of the seminary. She began to teach at a small school. Later, the beautiful brick building known as the Fedelia Fiske Seminary was erected. Dr. Joseph P. Cocran and Rev. David T. Stoddard later continued Dr. Perkins's work.

In the 1950s, another American missionary, Rev. Henry Lobdell, acted in Mosul, Mesopotamia. Most likely, the first Assyrian who visited America was Mar Yohannan, Bishop of Urmia, Iran. He was the instructor of Dr. Perkins in Old and Modern Assyrian. In 1841, Dr. Perkins invited him to visit America, and the Bishop spent 13 months here.

In September of 1882, Jacob Asfar landed in America. He was the first Assyrian from Diarbekir, Turkey. Soon he obtained a job as a silk weaver. Within six months, he learned English and specialized in photography.

About 1889, Mr. Nuworhaj came over from Urmia College to study Theology at McCormick Seminary in Chicago. He was one of the first Assyrians to come to Chicago. After his graduation, he returned to Tabriz.

In 1891, Isaac Adams, graduated student of Urmia College, was sent by the Presbyterian mission to Mr. Moody's School in Chicago. In 1892, he transferred to the Garrett Bible Institute in Evanston. In 1900, he published some books about Persia.

In 1892–93, people followed Mr. Nuworhaj, among them Dr. Jesse Yonan, who entered the Rush Medical College in Chicago and received a degree in 1897. He became a citizen of the United States, but returned to Persia as a medical missionary. In 1919, he was one of the delegates who represented Assyrians of Persia in the Paris Peace Conference. Later, he practiced medicine in Chicago.

Many Assyrians who were war refugees settled in a poor section of the city's Near North Side. Assyrians worked as house-painters, bricklayers, tailors, carpenters, contractors, factories, hotel workers, and janitors. Without knowledge of English, they tried to get a good job, an education, and to affiliate themselves with an American society.

Assyrians of Chicago mostly represented six different churches: Presbyterian Church, Holy Catholic Apostolic Church of the East (Assyrian), Congregational Church, Baptist Church, Pentecostal Church, and the Catholic Church. Rev. Malech mentioned in his book that, ". . . Assyrians opened their churches to have their meetings and religious worship even if they didn't have a church or hall of their own. Rev. H. Ablahat, a Presbyterian minister, had opened a mission for the Assyrians at West Chicago and held services there. Mr. H. Alamshah held his meetings in the Baptist church on La Salle Avenue for the young Assyrians belonging to his denomination. Mr. A. Urshan had his own mission on Clark Street for the Assyrians who have joined the Pentecostal brethren who speak with tongues, and some Assyrians have joined the Catholic Church."

General immigration of Assyrians to the United States began at the end of the nineteenth and at the beginning of the twentieth century. Looking for jobs, Assyrians dispersed in different directions all over the country. Initially, they planned to find jobs just to earn some money and to help their families back home. Gradually, Chicago became the main center of Assyrian immigration in the United States.

On February 19, 1909, the Christian Endeavor Society was organized. Rev. Paul Newey, who graduated from Urmia College (1904) and Chicago Theological Seminary (1913), was its first president (later his position was occupied by Qostantinus Alamshah, Abraham Lazar of Ada, Pera Daniel of Ada, and Yuel Yukhannan of Gulpashan). This society was founded to help in mission work.

In 1914, there were about 2,000 Assyrians in Chicago. In 1915, Paul S. Newey began to publish *"Assyrian-American Herald,"* the first Assyrian newspaper in Chicago. He also created the Assyrian Press, with its own East Assyrian types. He published many books in Assyrian, and his press was used by many Assyrian authors and publishers.

In 1917, a number of Assyrians invited Rev. Joel Warda, who lived in New York, to speak at a meeting in Chicago. As a result of his presentation, the Assyrian American Association of Chicago (or the Assyrian National Association of Chicago) was created. In 1919, delegates from the Assyrian American Association of Chicago—Jonathan Colia and Bishop Mar Yawalaha—represented the city at the Fourth Annual Convention of Assyrian National Associations of America (president of the ANA was Joel Warda) in New Britain, Connecticut. Jonathan Colia was elected as a chairman of the convention.

On December 17, 1918, residents of Geogtapa Village in Iran organized their society in Chicago under the name "The Relief Society of Geogtapa," with its president, Benjamin Marshall. The society had its own constitution. Similar organizations were established by former residents of Ardishay, Gulpashan, Alwach, and others.

As we discovered, there was also the Persian National League of Chicago in the 1920s. In 1932, John Baba published the *Assyrian Chronicle (Ktawuna)*, at The Assyrian Press, 58 West Huron Street. The Assyrian Youth Organization's directory of 1935 mentioned that there were 16 organizations and clubs in Chicago.

In 1935, T.D. Thomas (Shimshun David Thoma) of Chahrgushi published *Sparzona Monthly* at 301 Center Street. In 1936, *Sparzona* listed all organizations at that time in Chicago.

Churches:

Presbyterian Church—Rev. Haidow Ablahat
Evangelical Church—Rev. Paul Newey
Nestorian (Church of the East)—
 Rev. Shimon Tarverdi
Nestorian (Church of the East)—
 Rev. Shimon Yonan
Nestorian (Church of the East)—
 Rev. Sargis Benyamin

Catholic Church—Rev. Fransis Thoma
Brothers Church—Brother Jacoub
Pentecostal Church—Rev. Elisha
Pentecostal Church—Brother Iskhaq (Isaac)
Lutheran Church—Luther Pera

Organizations:

Assyrian United Council
National Association
Athletic Club
Youth Organization
Geogtapa Society
Ardishay Society
Highlanders' Society
Mar Ephraim Society

Tyari Society
Alwach Society
Iryawa Society
Wazirawad Society
Ladies of Siporghan
Ladies of Ardishay
Ladies of Gulpashan
Girls of Atour

Presbyterian Church

In 1902, there were about 30 Assyrians from Iran in the city. One of them was Sargis Y. Baaba. He began to attend the services of the Fourth Presbyterian Church, and a year later he united with the church. In 1905, under the pastorate of the Fourth Church, a Persian mission was

started. S. Baaba began to teach a bible study for his countrymen in connection with the church Sunday school. About that time, Assyrians organized an Assyrian Benevolent Society, and S. Baaba became as its first president. Its meetings were held monthly. Members of this organization helped their needy brothers and sent large gifts to the sufferers in Iran.

In the autumn of 1906, Mr. Haidow Ablahat of Tkhuma came to Chicago and entered as a student at McCormick Theological Seminary. In May 1908, Rev. Ablahat graduated from the seminary and became the minister of the Assyrian congregation. In September of 1910, the Woman's Sewing Society was organized under the head of Mrs. Haidow Ablahat (Rabi Khurma). This society was reorganized in 1915. From 1910 to 1919, the heads of the society were Rabi Khurma Ablahat, Rabi Sona Matti, Rabi Khanna Sargis of Geogtapa, and Rabi Maryam Baba Ishaq of Digala.

It was suggested that the Carter Fund might well be used for the construction of an Assyrian Church. By 1912, the fund provided enough to build a chapel that would satisfy the needs of the Assyrian congregation. So in December 1912, under the leadership of Dr. John Timothy, the cornerstone of Carter Memorial Chapel was laid at 54 West Huron Street and named as a "Carter Memorial Persian Assyrian Chapel." It was completed on June 8, 1913.

In November 1915, the Fourth Church brought Dr. Shedd, a Presbyterian missionary from the Urmia mission in Persia, to speak, especially to the Assyrians, and to answer their questions about their homeland. That month, a letter arrived from another Presbyterian missionary, Dr. Fred Coan, detailing the destruction and ending, "I wonder whether the Fourth Church would help me some in the Geogtapa Church. We need money."

The tragic events in Iran had reached their incandescence. As a result of World War I, Assyrians, as Christian people like Greeks and Armenians of the former Ottoman Empire, were doomed to extermination. Hundreds of thousands were killed and lost in the flames of that tragic war. Some of them escaped into Russia and others to America, including Chicago.

In 1928, Alexandre Alamasha received a Bachelor of Divinity degree from McCormic Theological Seminary and was ordained as a Presbyterian minister. A graduate of Dubuque University, Dubuque, Iowa, he also studied at George William College and the University of Chicago. Then he was the minister at the Assyrian Presbyterian Church of Gary, Indiana.

From 1929 to 1949, Rev. Jacob David of Seir worked in a missionary in Chicago with the Chicago Tract Society. From then until 1963, he was known by many Assyrians as a guest preacher in various churches. The 1935 directory of the Assyrian Youth Organization shows us that Carter Memorial Church was still in service at the same address, 54 West Huron Street, under the head of Rev. Haidow Ablahat. As the years went by, the congregation grew numerically and financially. The old church became too small, and with the influx of new members, it soon became apparent that a new, larger church must be erected. On November 7, 1948, the new Memorial Assyrian Presbyterian Church was dedicated. Rev. H. Ablahat retired in June 1955, but he continued to work with Rev. Jacob David (who died in May 1967) for many years. In 1958, Rev. Robert Odishaw began to serve the Carter Memorial Presbyterian Church.

Assyrian Congregational Church

In 1919, Paul Newey of Titrush, Urmia, founded the Assyrian Evangelical Church, which later became the Assyrian Congregational Church. According to the directory of the Assyrian Youth Organization of 1935, the Assyrian Evangelical Church was located at 611–617 Wellington Avenue, and the pastor was Rev. Paul S. Newey. In 1937, he served at 4447 North Hazel Street.

Holy Catholic Apostolic Church of the East (Assyrian)

In 1910, Rev. N. Malech's group met at the St. James Episcopal Church. In 1917, Mar Timotheus Indian Metropolitan consecrated Benjamin Odisho at 118 West Huron. Rev. Odisho, who came to the United States from Persia in 1913, established the Assyrian Church

in Chicago in 1915. He was later one of the founders of the churches in Gary, Indiana in 1919, and also churches in New Britain, Connecticut; Detroit and Flint, Michigan; and Turlock and Fresno, California.

Rev. Shimun Yonan of Alsan served in Chicago from 1917 to 1919. In 1919, Bishop Mar Yawalaha represented Chicago at the Fourth Annual Convention of Assyrian National Associations of America. In 1925–26, Shaul (Saul) David Neesan of Kehey, Targawar, was ordained by Mar Tematheus. He served as Patriarchal Administrator in Chicago from 1938 until 1949, until the arrival of the Mar Eshai in 1940. In Chicago, several priests belonging to different church groups appeared, including: Qasha Gewargis Azzo of Tkhouma, Ishai Sliwoo of Tkhouma (died February 1955), Qasha Tarverdi, Qasha Sargis Benjamin, Qasha Sadouq, and others.

The 1935 directory of the Assyrian Youth Organization lists three Assyrian churches, including: Holy Catholic Apostolic Church of the East at 1805 Hammond Street and headed by Rev. Enuia Esmail, Holy Catholic Apostolic Church of the East at 1441 Cleveland Avenue and headed by Rev. Sargis Benjamin, and St. Michael's Assyrian Church at 1111 Belden Avenue and headed by Rev. Simon Yonan.

Sadouq d'Mar Shimun came to Chicago in 1939. He studied at the Chicago Theological Seminary and had an independent church as a result of his conflict with Mar Eshai. Patriarch Catholicos Mar Eshai Shimun came to Chicago in 1940, and he settled here one year later. He replaced his patriarchal See from Iraq to the Ridgeview Hotel in Evanston, and then to 6346 North Sheridan Road in Chicago. He was then able to present his national petition before the World Conference at San Francisco in 1945, and before the United Nation Organization in 1947.

In 1961, Rev. Aprim Elias de Baz came to Chicago. Originally from Jezira, Syria, he was the sixth priest of the priest's family of the Baz district. He received his religious education at the Theological Seminary of the Church of the East at Khabur, Syria, which was founded by His Holiness Mar Eshai Shimun. Rev. Aprim was ordained a deacon in 1956, by Mar Joseph Khanisho, Metropolitan of Iraq in Khabur, Syria. He served two years in the villages of Tel Roman (upper), Tel Baz, and Tel Jezira. In 1958, he was ordained a priest in Baghdad by Mar Esho Sargis, Bishop of Jeloo. He was appointed by Mar Eshai Shimun to serve at Mar Sargis Church.

Chaldean Catholic Church

Rev. Peter Elia, from Iran, was the first priest of the Assyro-Chaldean community of Chicago, which originated in 1907. Rev. Warda Mirza, also from Iran, succeeded Rev. Elia. He established the St. Ephrem Chaldean Parish of Chicago in 1912. Rev. Samuel David came to Chicago and began to serve in 1913. He received his education in Marseilles, France. Rev. Samuel David published several books in Assyrian, including the first English-Chaldean and Chaldean-English dictionary, which was published in Chicago in 1924. Rev. Simon Joseph, also from Iran, served in Chicago in 1934. Rev. Msgr. Francis Thomay arrived in Chicago in 1935. He received his education in Beirut under the French Jesuit Fathers of Beirut. In 1952, Rev. Thomas M. Bidavid came to Chicago to succeed Msgr. Thomay. That same year, Rev. Sada Yonan came to Chicago to assist Rev. T.M. Bidawid.

Assyrian Pentecostal Church

In 1909, Rev. Andrew Urshan served the Persian Pentecostal Mission at 821 North Clark. He opened a new mission in 1920. In 1936, *Spazona Monthly* listed two churches, including the Pentecostal Church headed by Rev. Elisha, and the Pentecostal Church headed by Brother Iskhaq (Isaac).

Assyrian Lutheran Church

The Assyrian Lutheran St. George Church was led by Pastor Luther Pera in the 1930s. This church was located at Goethe and 1300 North LaSalle.

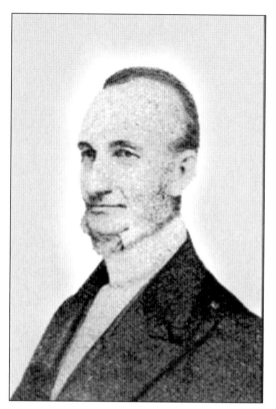

Pictured here is Dr. Justin Perkins. He was a pioneer of the American Mission among the Assyrians in Persia. Dr. J. Perkins organized English classes in their mission with his colleagues. American missionaries installed the printing press for publishing. They spent years translating old Assyrian books of religion into the modern language and published them (about 30 publications) at a new mission publishing press. In 1836, Dr. Perkins organized the first mission school for the Assyrians in Urmia. Later it was reorganized into two institutions— Qalla College for boys and Fiske Seminary for girls.

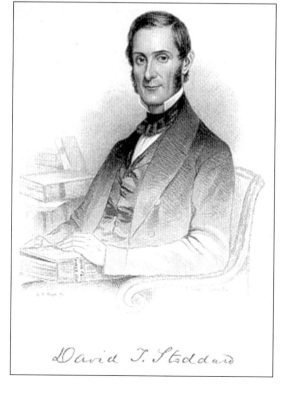

This is a lithographical portrait of Rev. David Tappan Stoddard, who was a missionary to the Assyrians of Persia. In 1842, he completed the application to be appointed to the Assyrians as a missionary. He closed with this statement: "My feelings have been gradually interested, until it seems to me that I can leave my friends and my country and joyfully live among the Assyrians." His memoirs were published by J.P. Thompson, D.D., New York, 1858.

This is a lithographical portrait of Rev. Henry Lobdell, M.D., made by A.H. Ritchie. Rev. Lobdell was a missionary of the American Board at Mosul. He described being in Mesopotamia in 1852, in his diary, which was published in Boston in 1859 by Rev. W.S. Tyler, D.D. It was a tribute to the Assyrians—their traditions, life, and history.

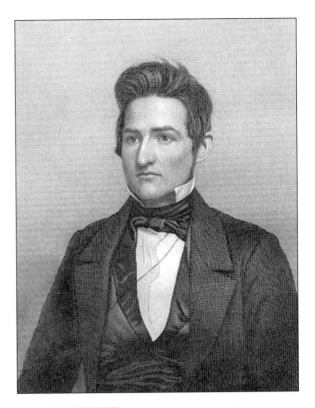

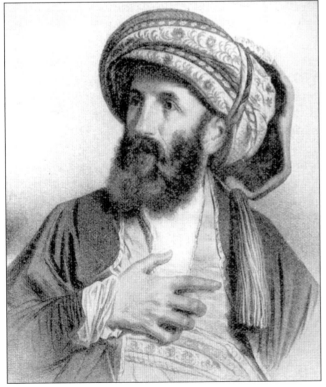

This is a portrait of Bishop Mar Yohannan. Mar Yohannan, bishop of Urmia, visited America with Dr. Perkins in 1842. They were the pioneers of the American mission among the Assyrians in Persia. Mar Yohannan was an instructor of Dr. Perkins in the Assyrian language. He later helped American missionaries to prepare and translate many religious books from old Assyrian to the modern language.

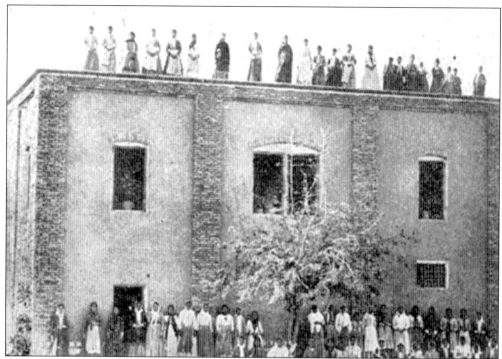

Pictured above is Fiske Seminary in Urmia, Iran. Fedelia Fiske was a founder of the seminary. She began teaching at their small school on June 14, 1843. A beautiful brick building was later erected and was known as the Fedelia Fiske Seminary.

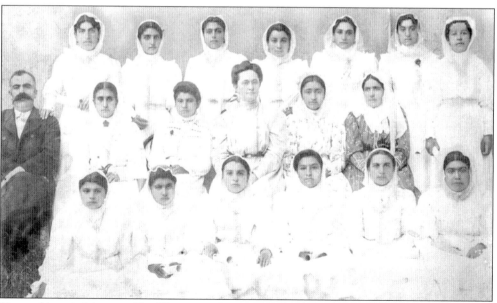

Pictured here is Margaret Shedd's group of women at the Fiske Seminary.

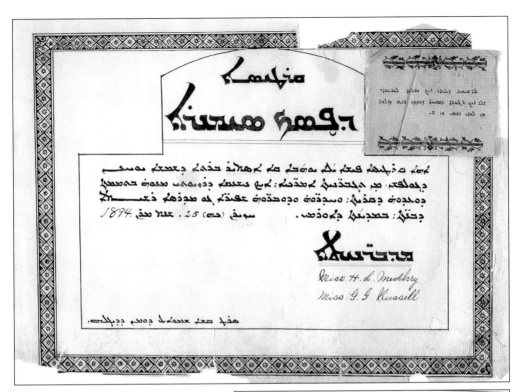

This is a reproduction of the certificate of Fiske Seminary, which was given to Ister Yukhannan of Gulpashan in 1894. It was signed by teachers Miss H.L. Medbury and Miss G.G. Russell and was written by Rev. Shmoel (Samuel) Duman of Digalah.

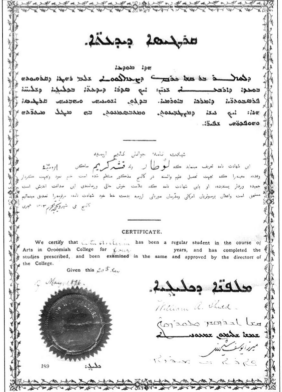

Shown here is a reproduction of the certificate of Urmia College that was given to Luter Karam (son of Rev. Karam of Satluveh) in 1894, for four years of courses in the arts. It was signed by teachers William A. Shedd, Rev. Abraham Murhach, Deacon Shlimon Shimonaya, Mirza Joseph, and Pera B. Mirza.

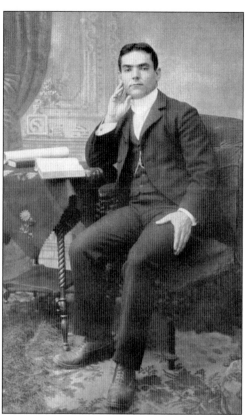

This is a portrait of Isaac Adams, author of *"Darkness and Daybreak"* and *"Persia by a Persian."* In 1892, he studied at the Bible Institute in Evanston.

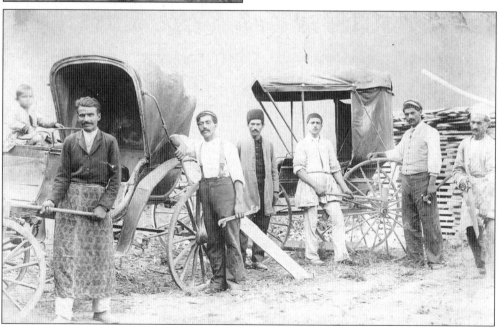

This is a photo of Shimon Ganja's group at the beginning of the twentieth century. Shimon Ganja is standing second from the right. In 1919, he was one of the delegates who represented the Assyrians of Russia in the Paris Peace Conference. He lived in Iran and later moved to Chicago.

Dr. Shedd, Dean of the American Mission and the American Vice Consul in Urmia, died as a martyr for the cause of Christ during the last exodus of the Assyrians from Urmia.

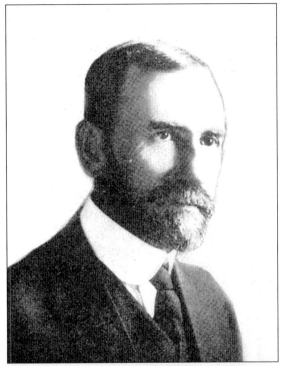

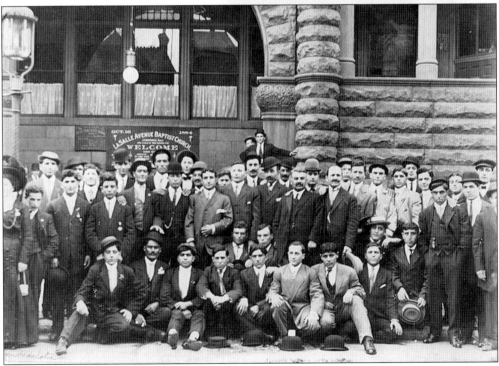

This is a picture of Rev. H. Alamshah's group, who were the first Assyrians to come from Urmia to Chicago in 1903. They held their meetings in the Baptist church on La Salle Avenue. From left to right, eleventh in the second row, is Rev. H. Alamshah, standing with a hat in his left hand.

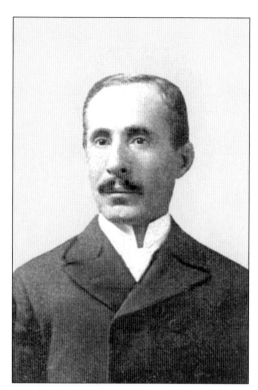

Pictured here is Mooshie G. Daniel in October 1895. He graduated from Urmia College in 1882, and entered McCormick Seminary. Later he became Professor of Ancient Syriac at Urmia College. In 1897, he published *"Modern Persia,"* Wheaton, Illinois.

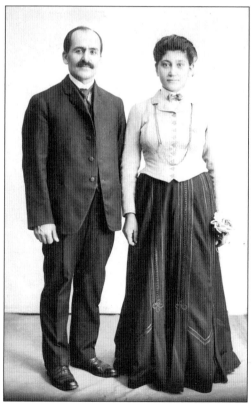

Pictured here are Rev. H.O. Alamshah and his wife, Susan, on June 25, 1905, in Chicago.

This is a photo of Rev. Nestorius Malech, son of Prof. Gewargis Malech. He was co-author of his father's book, *"History of the Syrian Nation and the Old Evangelical-Apostolic Church of the East,"* published in 1910.

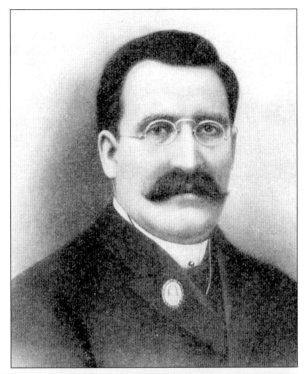

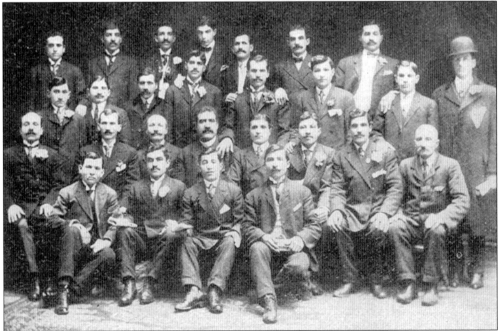

This is a photo of The Persian Christian Benevolent Society. In 1906, Rev. Nestorius Malech organized The Persian Christian Benevolent Society at the Methodist church on LaSalle Avenue. Then it was moved to the Fourth Presbyterian Church at the corner of Cass and Huron Streets. There were about 100 members there. The society provided assistance for newly arrived immigrants in Chicago.

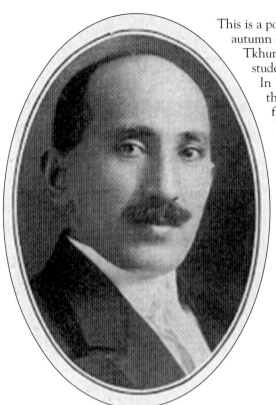

This is a portrait of Rev. Haidow Ablahat. In the autumn of 1906, missionary Haidow Ablahat of Tkhuma arrived in Chicago. He became a student of McCormick Theological Seminary. In 1907, he conducted evening classes for the study of English. After his graduation from the seminary, he was ordained Doctor of Divinity by Presbytery of Chicago. With S. Baaba's cooperation, he was engaged as a minister to the Persian Assyrians.

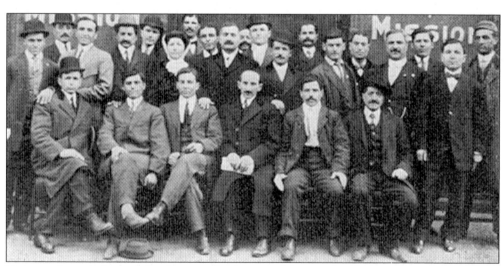

Here are the members of the Assyrian Presbyterian Mission. In 1905, under pastorate of the Fourth Church, a Persian mission was started. Rev. H. Ablahat, the pastor (sitting at the center with a bundle in his hands), says in his report for the year: "I am very glad that we have this chapel. It is a center for our people socially, educationally, and spiritually. It is our church, our school, our library, our post office, and our home. As the ancient temple in Jerusalem was for the Jews, so is the Carter Memorial Chapel for us."

This is a photo of the church at 54 West Huron Street in 1919. The population of the Assyrian community in Chicago increased day by day, and Assyrians had to rent a mission hall on Chicago Avenue, where the various meetings and classes could be better served. It was suggested that the Carter fund might well be used for the construction of an Assyrian Church. By 1912, the fund provided enough to build a chapel that would satisfy the needs of the Assyrian congregation. So in December 1912, under the leadership of Dr. John Timothy, the cornerstone of Carter Memorial Chapel was laid at 54 West Huron Street and named as the Carter Memorial Persian Assyrian Chapel. It was completed by June 8, 1913.

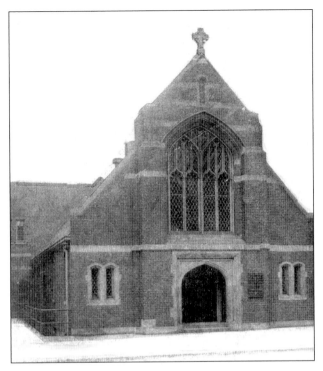

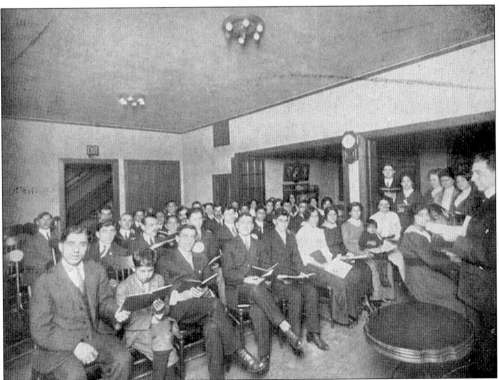

This is a photo of the Sunday School at the Carter Memorial Assyrian-Persian Chapel of the Fourth Presbyterian Church.

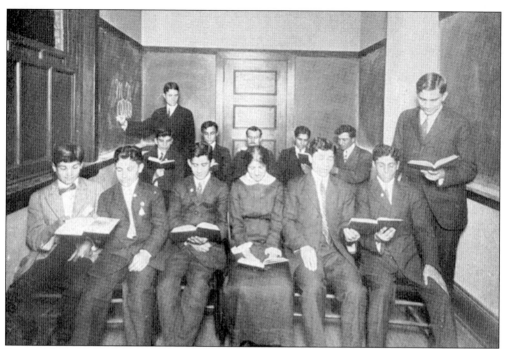

Pictured here are members of the Sunday School at the Carter Memorial Assyrian Church.

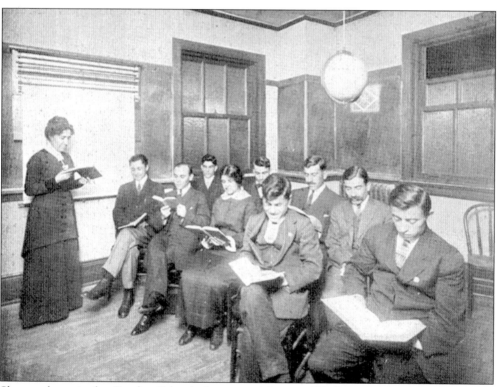

Shown above is the Sunday School classroom. Margaret W. Dean is pictured teaching an English class for Assyrians in the night school at the Carter Memorial Assyrian Church.

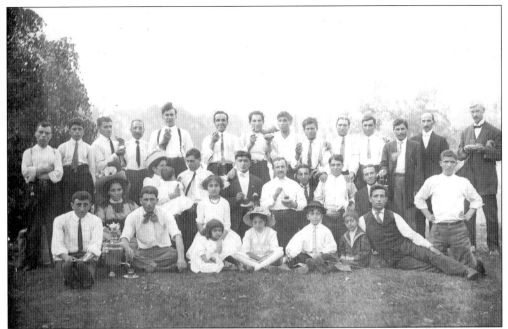

Pictured above are members of the Christian Endeavor Society. This photograph was taken in 1913 at Garfield Park. The society was organized on February 19, 1909, with 13 members. The society always cooperated with both the North Division and the Chicago Christian Endeavor Union.

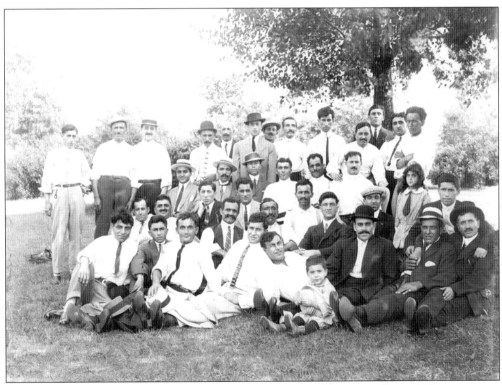

Members of the Assyrian National Organization are pictured here on July 4, 1913.

Pictured here in 1911 is Andrew D. Urshan, founder of the Persian Pentecostal Mission, located at 821 North Clark Street in Chicago.

ܟܬܒܐ

ܕܟܐܬܘܫܚܬܐ ܡܕܝܐ̈

SONGS OF PRAISES

A SYRIAC HYMN BOOK

EDITED BY

ANDREW D. URSHAN Evangelist.

ܒܝܕ

ܡܫܝܚ ܐܘܢܓܠܣܛܐ ܕ. ܐܘܪܫܢ ܕܐܘܪܡܝܐ.

ܒܕܦܘ

ܒܡܫܟܕܢܐ ܣܘܪܝܝܐ ܕܫܝܟܓܐ ܗܘܦܐ.

ܫܢܬ ܀ 1916

This is a reproduction of the cover of *Songs of Praises: A Syriac Hymn Book*, by Andrew D. Urshan (Evangelist). The book was published at Mashkhedana Suryaya Press, Chicago, 1916.

Pictured here is Rev. Paul Sarkhosh Newey. He was born at Titrush, Urmia, on October 8, 1885. He graduated from the Urmia Preparatory School in 1899, and received an A.B. degree from Urmia College in 1904. He was the principal at the Gulpashan School (Iran) from 1904–05, and Geogtapa School from 1905–06. He came to the United States in 1906. On February 19, 1909, the Christian Endeavor Society was organized, and he became its first president (later his position was occupied by Qostantinus Alamshah, Abraham Lazar of Ada, Pera Daniel of Ada, Yuel Yukhannan of Gulpashan). This society was founded to help carry out mission work. Rev. Newey was awarded his Bachelor of Divinity degree from Chicago Theological Seminary in 1913, and was ordained to the ministry. Rev. Newey was joined in marriage with Mary Yonan on September 1, at the Carter Memorial Church, and from this union Paul Davis, Harold Wilbur, Marie Laily, Donald Wesley, and Carl Timothy were born. From 1915 to 1919, he was editor and publisher of the *American-Assyrian Herald*, the first Assyrian newspaper in Chicago. Also he created the Assyrian Press with its own east Assyrian types. He published a lot of books in Assyrian, and his press was used by many Assyrian authors

and publishers. In 1919, he organized and became the pastor of the Assyrian Evangelical Church, which later changed its name to the Assyrian Congregational Church. The same year, he published his *Poetry in Syriac*. In 1929, he published his *New Syriac Hymnal*. From 1946 to 1948, he was the chairman of the Assyrian Political Action Committee and member of the Council of Assyrian Societies. He helped more than 1,000 persons to become United States citizens.

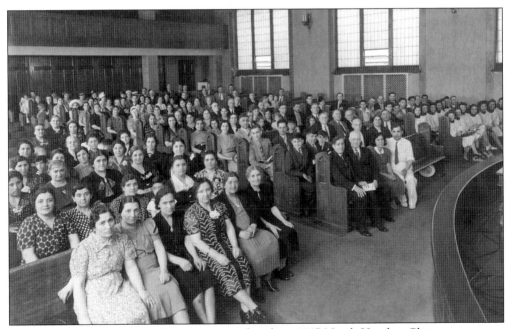

Pictured here are members of Rev. Newey's church at 4447 North Hazel in Chicago. (Photograph by Herbert G. Gotshall Commercial.)

ܟܬܒܐ ܕܥܠ ܦܠܫܐ

ܘܥܠܡܐ ܐܢܫܝܐ

ܡܢ ܝܘܢܬܢ ܒܢܝܡܢ ܓܝܘܓܬܦܝܐ

ܐܬܒܥ

ܡܫܚܕܬܢܐ ܕܡܚܟܡܘܬܐ ܕܐܬܘܪܝ

ܚܝܩܓܘ 1916.

This is a reproduction of the *Poems on War*, published by Yunatan Benjamin of Geogtapa, at Mashkhedana Suryaya Press in Chicago, *c.* 1916.

Shown here is a reproduction of the *Assyrian Spelling Book for Beginners*, published by Mashkhedana Suryaya Press in Chicago, *c.* 1917.

ܟܬܒܐ ܕܗܘܓܝܐ

ܣܦܪܐ ܩܕܡܝܐ

Published by
ASSYRIAN AMERICAN PUBLISHING CO.
112 West Chicago Avenue
CHICAGO ILL. U. S. A.

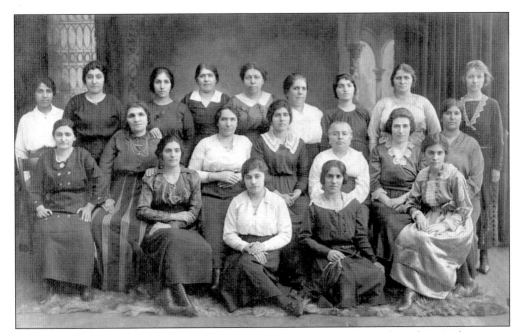

Pictured here are members of the Woman's Sewing Society. In September of 1910, the society was organized, headed by Mrs. Haidow Ablahat (Rabi Khurma). It was reorganized in 1915. Over the years, the society became more professional in nature.

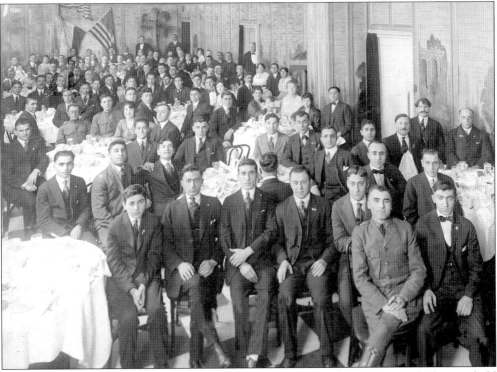

This is a photo of the Victory Banquet of the Assyrian National Association of Chicago, held at the Hotel Morrison on December 20, 1918.

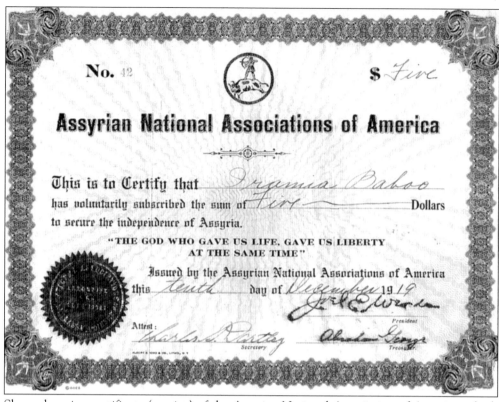

Shown here is a certificate (receipt) of the Assyrian National Association of America, which was given to Iramia Baba in 1919. It was signed by Joel E. Warda, president of ANAA, and Charles Dartley, secretary.

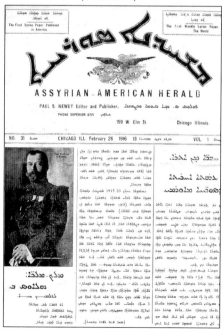

This is a reproduction of the *Assyrian-American Herald*, the first Assyrian newspaper of Chicago, which was published by Rev. Paul Newey from 1915 to 1919.

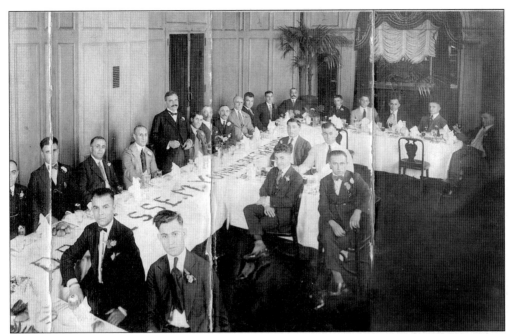

On December 17, 1918, Assyrian residents of the Geogtapa Village in Iran organized their society in Chicago under the name of The Relief Society of Geogtapa, and its president was Benjamin Marshall. The society had its own constitution. This picture was taken by the Burke and Friedmann Studio and depicts the banquet given by The Relief Society of Geogtapa in honor of Dr. Jesse (Eshai) M. Yonan at the Morrison Hotel in Chicago on July 29, 1920. Standing in the back is Dr. Yonan. He entered the Rush Medical College in Chicago and received a degree in 1897. He became a citizen of the United States but returned to Persia as a medical missionary. In 1919, he was one of the delegates who represented the Assyrians of Persia at the Paris Peace Conference. He later practiced medicine in Chicago.

Pictured here is Rev. Malkizdeq Z. Bacchus, who was born in Rezaieh, Iran, and attended the American college there. He came to America in 1918. Rev. Bacchus was a graduate of the Toronto Bible College and International School of Religion. Before he was engaged in evangelistic work in Chicago, he was the pastor of the Assyrian Presbyterian Church in Flint. He translated John Bunyan's book, *The Pilgrim's Progress,* which was published in 1931 by Aghajan Baba of Seiri at the Assyrian Press, 58 West Huron Street in Chicago.

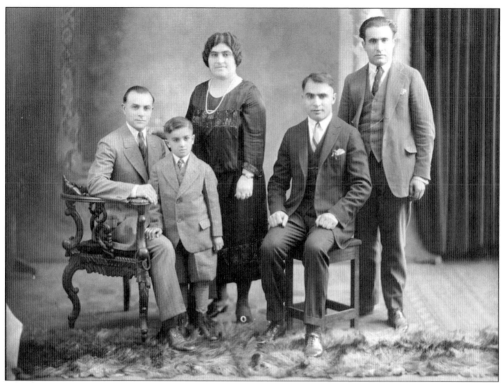

This is a family picture taken at the Alitto Studio at 678 North Clark Street in Chicago in 1920. From left to right are: Yuro, Raymond, Khanimjohn Benjamin, Carmen Baba, and Jonathan Baba.

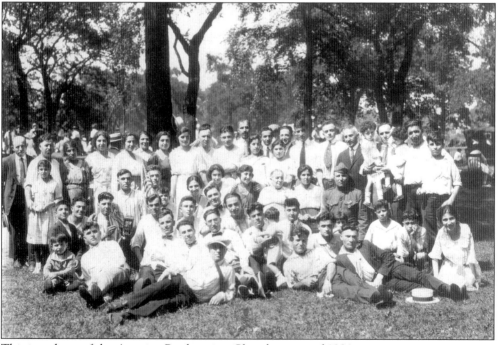

This is a photo of the Assyrian Presbyterian Church picnic of 1921.

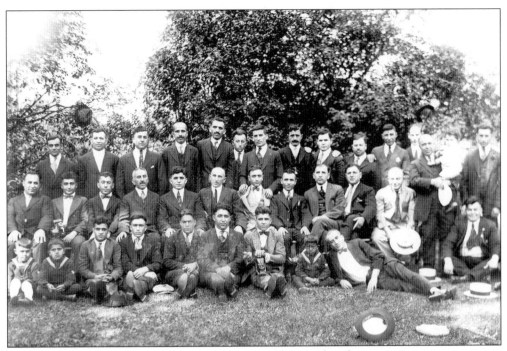

This is a photo of the Assyrian group of Rev. H. Ablahat's church at a picnic.

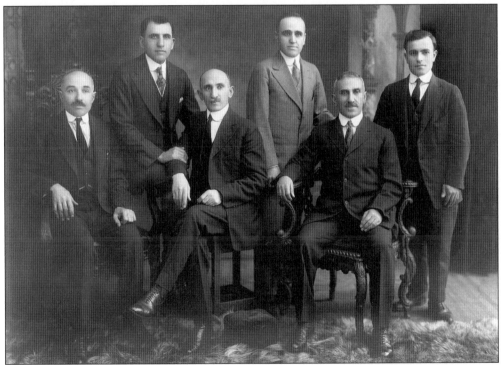

Here is a photo of the members and activists of the Fourth Presbyterian Church. Pictured are: Rev. Haidow Ablahat (third from the left), Alisha Shlimon, Abraham Lazar, Alkhas Shabas, Issa Matti, and Baba Shimon. This photograph was taken in Chicago in 1920.

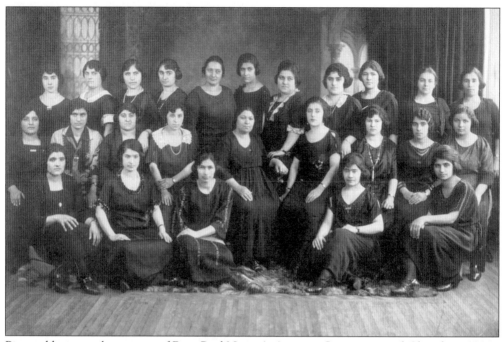

Pictured here are the women of Rev. Paul Newey's Assyrian Congregational Church, *c.* 1921.

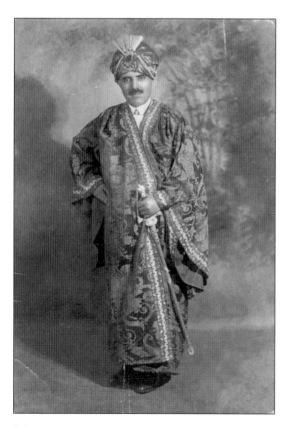

This is a photo of Baba Badal, a translator of Assyrian fables and an activist of the Church of the East, Chicago, *c.* 1921.

This is a reproduction of the passport of Samuel Joseph, a citizen of Iran who came to Chicago in 1927.

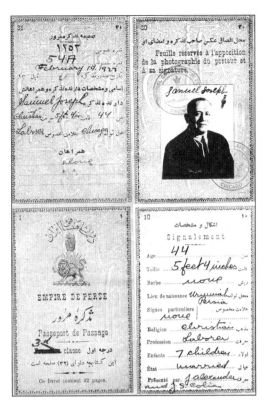

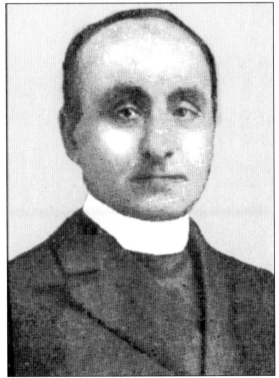

This is a portrait of Rev. Samuel David, who came to Chicago in 1913 to serve at the Assyrian Catholic Church (Chaldean). He published several books in Assyrian, including the first English-Chaldean and Chaldean-English dictionary, which was published in Chicago in 1924.

ܗܝܕܝܼܘܬ ܡܪܝܐ

ܕܬܫܥܝܼܬܐ ܦܫܝܼܛܬܐ ܕܝܘܣܦ

ܥܠ ܡܘܪܐ ܒܪ ܒܪ ܥܡܘܕܐ.

ܘܩܘܪܒܐ ܠܟܪܘܒܐ ܒܪܝܐܐ

ܒܪܝܐ ܡܘܪܐ ܒܪܝܐ ܣܘܪܝܝܐ.

✿ ✿

The
Complete History
Of
Joseph The Patriarch
composed poetically
By
Saint Ephraim
The
Syriac Doctor
Of
The Church.

ܘܣܘܪܝܝܐ ܕܟܪܝܐ 1925.

ܕܟܪܝܐ ܡܘ ܒܪܝܐ.

Shown here is a reproduction of the cover of *The Complete History of Joseph Patriarch*, which was published by Rev. Samuel David in Chicago in 1925.

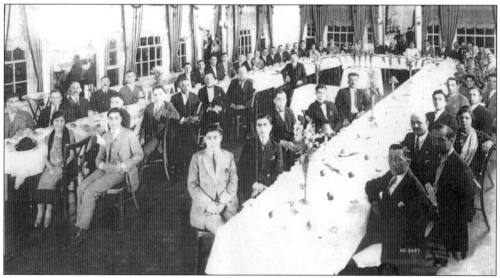

This banquet was given in honor of Lady Surma, sister of patriarch Mar Benyamin Shimun, by the Assyrian (Nestorian) Church of the East at the Webster Hotel on May 6, 1926.

This is a photo of Samuel Joseph, a member of the Persian National League of Chicago, and his membership card of December 12, 1927.

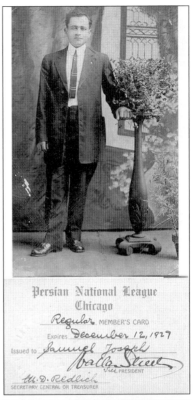

Pictured here is an Arshin Mallalan play performed in Chicago in 1927.

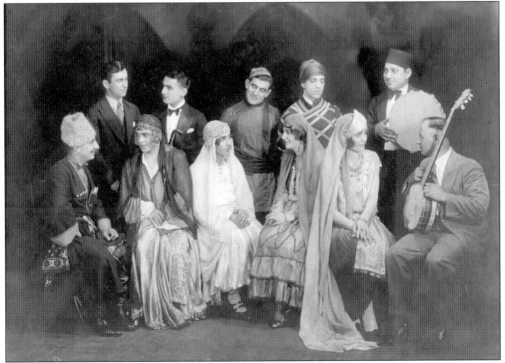

Shown here is the women's group of Rev. Hormizd Alamshah in Chicago, *c.* 1933.

Pictured here is the Silver Jubilee Mass of Rev. Francis Thomay, who was ordained in 1911 at Beirut, Syria. It was held at St. Michael's school hall at Eugenie Street and Cleveland Avenue. From left to right, in the back, are Father Thomay, celebrant; and David Khubiar, deacon. This photograph was taken May 3, 1936, in Chicago.

This is a photo of Rev. Shaul David (Nisan) of Kahey, Targawar. In 1925–26, he was ordained by Mar Tematheus. In 1938, he was patriarchal administrator until Mar Eshai arrived in Chicago in 1940. From 1948–51, he served as vice-president of the Patriarchal Council.

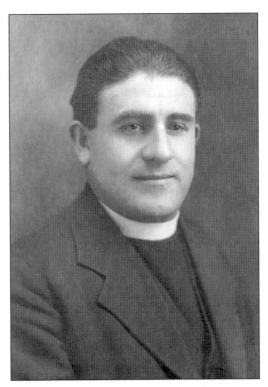

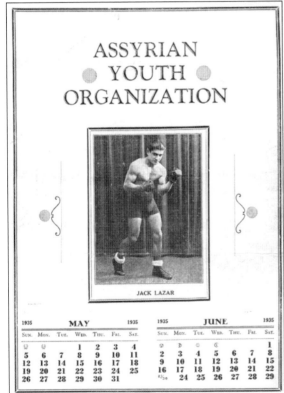

This is a cover of a 1935 directory of the Assyrian Youth Organization in Chicago. Boxer Jack Lazar, a member of the AYO, is pictured on the cover.

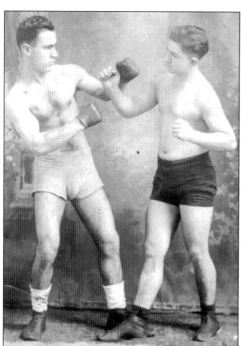

Two boxers are pictured here. The man on the left is Ilias Awshalum.

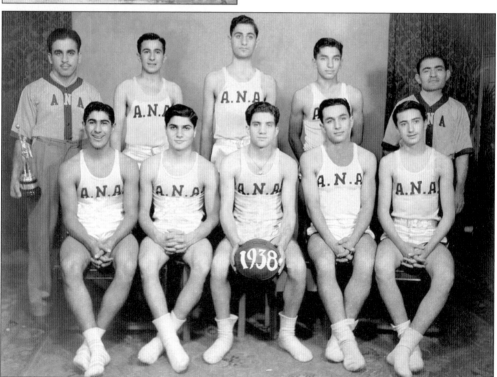

Pictured here is the basketball team of the Assyrian Youth Organization, 1938. The team is shown here, from left to right: (back row) Samuel Sayad, Fred Barkoo, Bill Lanky Benjamin, Jimmy Malick, John Hosanna; (bottom row) Bob Abraham, John Abraham, Bob Benjamin, Wilson Malick, and David Yohannan.

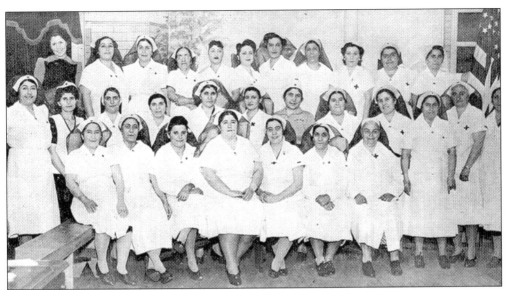

Pictured here is the Assyrian American Association Ladies Auxiliary Red Cross, *c.* 1936.

Shown here is a copy of the *Assyrian Chronicle* (Ktawuna). The magazine was edited and published by John Baba from 1932 until 1937, at the Assyrian Press at 58 West Huron Street in Chicago.

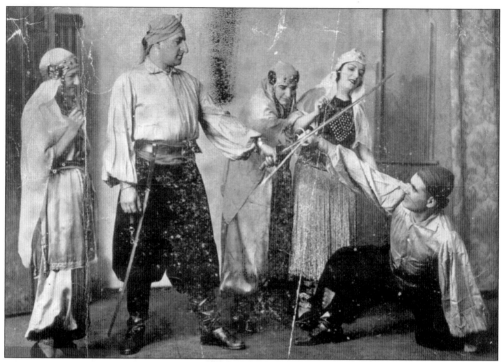

This photograph depicts a scene from the play *Nowruz*, performed at 1016 North Dearborn Street in Chicago in 1937.

This is a reproduction of the cover of *Sparzona* magazine, *c.* 1935, published by T.D. Thomas (Shimshun David Thoma) of Chahrgusha until 1939, then at 301 Center Street in Chicago.

This is a photo of "Yuel Tutrush" John Jonan.

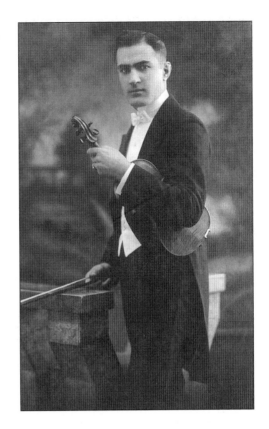

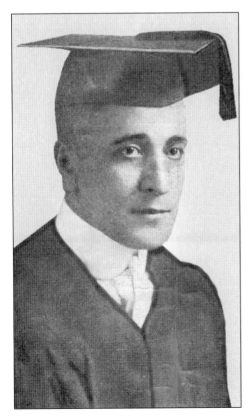

This is a portrait of Dr. Khedroo Shappoo. He went to the Episcopalian Missionary School in Urmia in 1901, then he came to America. When he was in Urmia, he copied several old manuscripts and brought them to America. After working two years in Chicago, he went to the Grand Prairie Seminary in Onarga, Illinois. Here he worked and studied earnestly for five years, receiving two diplomas—one from the academy and the other from the oratory department. He won three gold medals—one in debating and two in oratorical contests. Dr. Khedroo began his studies at the Chicago College of Dental Surgery in 1914, and he graduated in 1917. Dr. Khedroo had a dental practice in Chicago for 19 years, with one of the best equipped dental offices in the city.

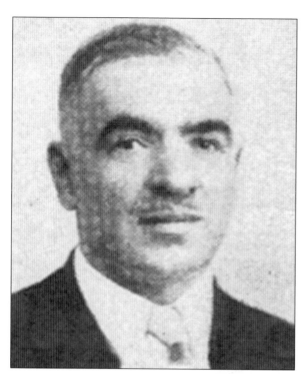

Pictured here is Pastor Luther Pera, of the Lutheran church of Wazirawa. He served in Chicago in the 1930s. He translated a book of Dr. Martin Luther, which was published in 1932, by Ephraim Abraham at the Assyrian National Press located at 3434 North Halsted Street in Chicago.

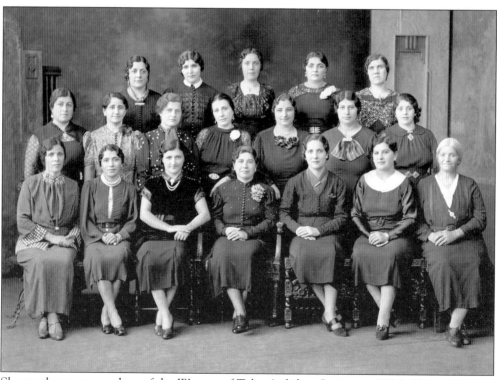

Shown above are members of the Women of Taka-Ardishay Society, c. 1936, Chicago.

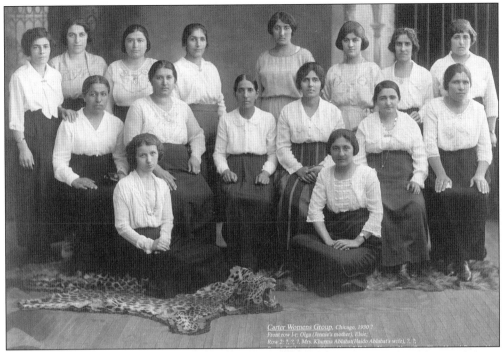

Carter Womens Group, Chicago, 1930 ?
Front row l-r: Olga (Jennie's mother), Elsie;
Row 2: ?, ?, ?, Mrs. Khurma Ablahat(Haido Ablahat's wife), ?, ?;

Pictured above are members of the Women's Sewing Society.

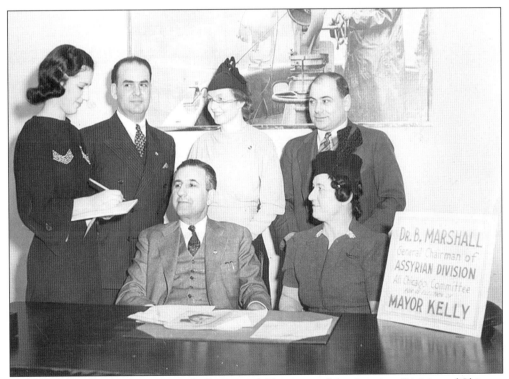

Dr. B. MARSHALL
General Chairman of
ASSYRIAN DIVISION
All Chicago Committee
for re-election of
MAYOR KELLY

Pictured here is Dr. Benjamin Marshall, General Chairman of the Assyrian Division of Chicago Committee for Re-election of Mayor J. Kelly.

This is Dr. Benjamin Marshall's group, the Assyrian Political Action Committee for the Re-election of Mayor J. Kelly, c. 1939.

MAYOR EDWARD J. KELLY

AN OUTSTANDING EXECUTIVE A FIGHTER FOR CHICAGO'S WELFAR

A. A. SPRAGUE, General Chairman

9TH FLOOR, CONWAY BLDG.
111 WEST WASHINGTON ST.
TELEPHONE ANDOVER 3400

DR. BEN MARSHALL
General Chairman

JONATHAN PAUL
General Secretary

CYRUS S. MOORAD
Treasurer

Committee:

THE REV. PAUL S. NEWEY
SHIMMON GANJA
DR. JESSE M. YONAN
JOSEPH DAVADOO
DR. NATHANAEL WANDA
TOM D. THOMAS
DR. K. S. KHANANOO
DR. JERRY B. NIRASON
UROY YACOB
DR. JESSE DANIELS
SOLEMMON M. YONAN
MRS. SURETTE JOSEPH
MRS. ALICE WANDA
SAM DAVADOO
ABRAHAM SARGIS
MRS. MARIAM ODISHOO
ORAHA-ODISHOO
JOHN LA ZAAR
JOHN JOSEPH
JESSE YACOB
RAYMOND BENJAMIN

Vice Presidents
Women's Division

MRS. JENNY JOSEPH
Chairman, Women's Division

MRS. OLGA DAVADOO
MRS. SHUSHAN EROOO
MRS. KATHMEONN BENJAMIN
MRS. KATHERINE ESMAIL

ASSYRIAN-AMERICAN DIVISION

February 17, 1939

To All Assyrian-Americans of Chicago:

Four years ago, when Mayor Kelly was a candidate to succeed himself, the Assyrian Political Action Committee endorsed Mayor Kelly's candidacy and urged every Assyrian-American to vote for him. Mayor Kelly was elected by the biggest majority ever given a candidate for that office.

His great accomplishments during the last four years are known to all of you. All we need say is that we are proud of his record and let that record speak for itself.

Today Mayor Kelly is again a candidate for the high office of Mayor of Chicago. He is the same man of four years ago, except he is much richer in experience.

After a thorough consideration of the qualifications of his opponents, we are convinced Mayor Kelly is the only candidate who is truly worthy of the great name of Chicago.

Therefore, we, through the Assyrian-American Committee for the re-election of Mayor Kelly, again urge you all to go to polls on Tuesday, February 28, and ask for the Democratic ballot and

VOTE FOR MAYOR KELLY.

Sincerely yours,

The Assyrian-American Committee for the Re-election of Mayor Kelly.

Dr. Ben Marshall, General Chairman
Mrs. Jenny Joseph, Chairman,
Women's Division
Jonathan Paul, General Secretary

This is a letter of support from the Assyrian-American Division for the re-election of Mayor E.J. Kelly.

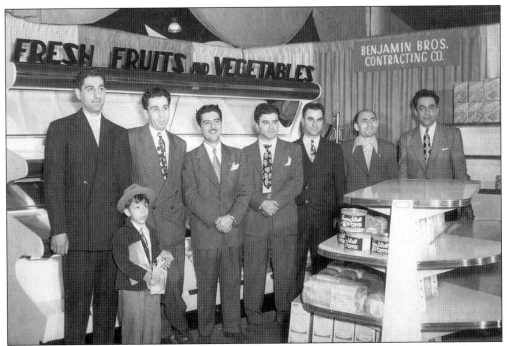

Pictured above are attendees at the Contractor Convention in the 1940s. It was held at the Amphitheater at 42nd and Halsted Streets. Standing, from left to right, are: Bill Benjamin, unidentified boy, George Benjamin, Leonard Joseph, Bill Elia, John R. John, John Hosanna, and John Lazar.

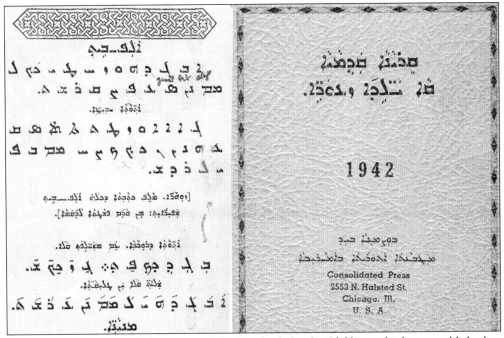

This is a reproduction of the cover of the *Textbook for the Children*, which was published at Consolidated Press, located at 2553 North Halsted Street in Chicago.

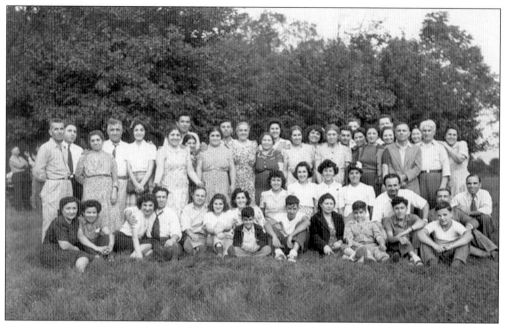

Pictured here is the Geogtapa Society picnic, held in the summer of 1942.

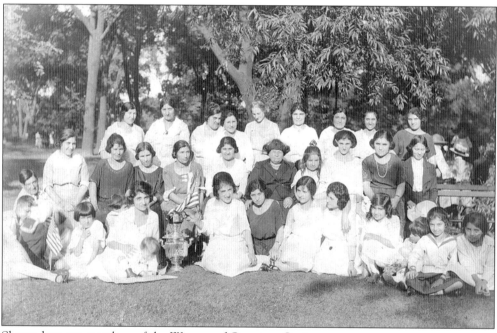

Shown here are members of the Women of Geogtapa Society.

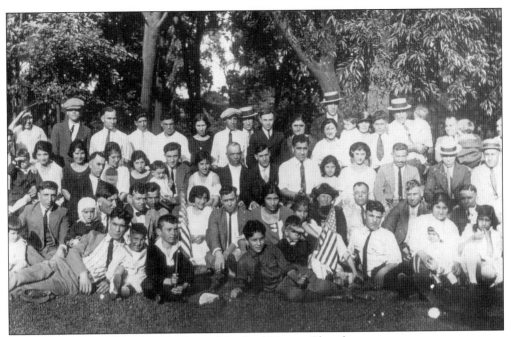

This is a picnic held for the members of the Paul Newey Church.

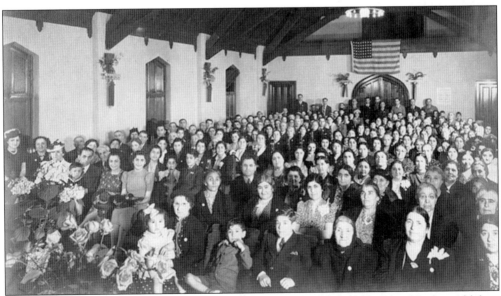

Pictured above are members of the Carter Memorial Church, headed by Rev. Haidow Ablahat, in 1942.

SOCIAL SECURITY ACT
ACCOUNT NUMBER
323-07-2015
HAS BEEN ESTABLISHED FOR

John Odisha

12-11-36
DATE OF ISSUE EMPLOYEE'S SIGNATURE

This is a reproduction of the Social Security card of John Odisha, *c.* 1936.

Pictured here is Alexander Joseph Oraham. He was born in the Armootagadge Village of Iran. He moved to America in 1913. After he graduated from the Surgeon College of Microbiology in 1925, he established an x-ray laboratory in Chicago. He established The Consolidated Press printing company in 1941, at 2553 North Halsted Street. In 1943, Alexander Oraham published the first Assyrian-English Dictionary.

This is a dedication service booklet from the Carter Memorial Assyrian Presbyterian Church, c. 1948.

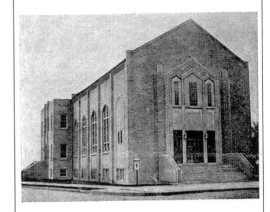

Pictured above is Rev. Haidow Ablahat at a Carter Memorial Assyrian Presbyterian Church service. He retired in June 1955. During his years of service, he baptized 522 children, performed 261 marriages, and officiated at 348 funeral services.

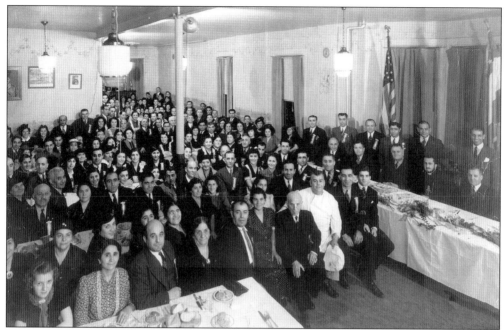

This is a photo of a banquet in honor of His Beatitude Mar Eshai Shimun, Catholicos Patriarch of the East. The banquet was held by the Assyrian National Association of Chicago on October 20, 1940.

In 1940, Patriarch Catholicos, Mar Eshai Shimun, came to Chicago, and he settled here one year later. He replaced his patriarchal See from Iraq to the Ridgeview Hotel in Evanston, and then moved to 6346 North Sheridan Road in Chicago. This is a photo of Mar Eshai Shimun, with members of his church in Chicago.

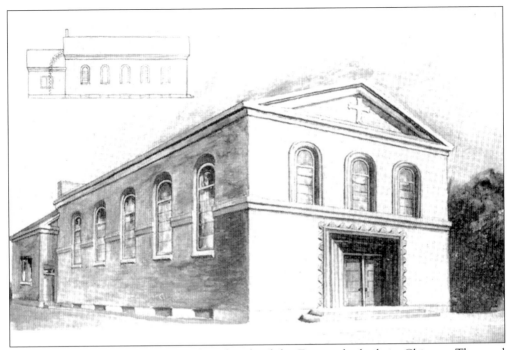

This is a sketch of a new church, the Church of the East, to be built in Chicago. The total amount required to fund this construction was $45,000. The money was raised, and this church was built and named the Mar Sargis Church.

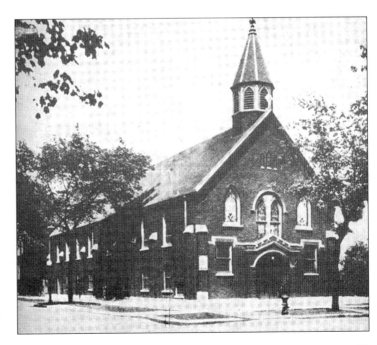

This is the Assyrian Mar Sargis Church of the East, located at 1850 Culver Avenue in Chicago, c. 1960.

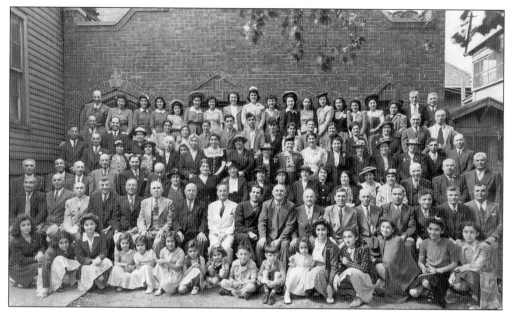

These are members of the Holy Catholic Apostolic Church of the East (Assyrian), with their minister, Rev. Sadook De Mar Shimun, on June 14, 1942.

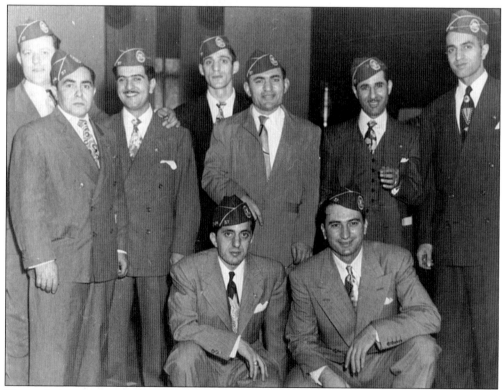

Pictured above are members of AMVETS Post 57, c. 1949. They are, from left to right: (standing) Robert Benjamin, Bob Thomas, Leonard Joseph, Ross Alexander, John Hosanna, Al Khamis, Fred Ganja; (seated) Marshal Joseph and Dave Yohannan.

Pictured here are the women of AMVETS Post 57, c. 1949. From left to right are: Pearl Joseph, Margaret Daniel, Josephine Wydra, Ann Benjamin, Julia David, and Habby Khedroo.

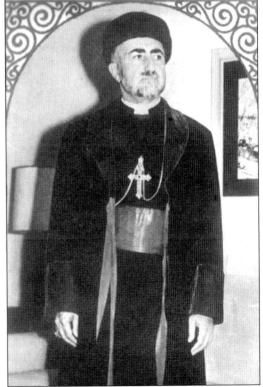

This is Patriarch Mar Eshai Shimun, who was able to present his National Petition as the "Assyrian Question" before the World Conference at San Francisco in 1945, and then before the United Nations Organization in 1947.

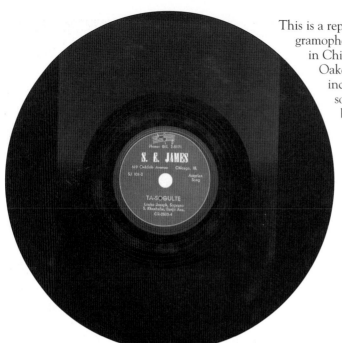

This is a reproduction of the first gramophone record, which was issued in Chicago by S.E. James at 619 Oakdale Avenue. Side A included: "Tutte Kush," with soprano Louise Joseph and banjo and accordion player S. Khanbaba; Side B included: "Ta Sogulte," with soprano Louise Joseph and banjo and accordion player S. Khanbaba.

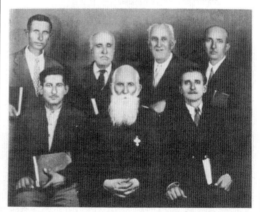

Shown here is a copy of the cover of the August-September 1950 issue of the *Light from the East* magazine, which was published bi-monthly by the Patriarchal Council in Chicago since 1948. They were located at 6346 North Sheridan Road.

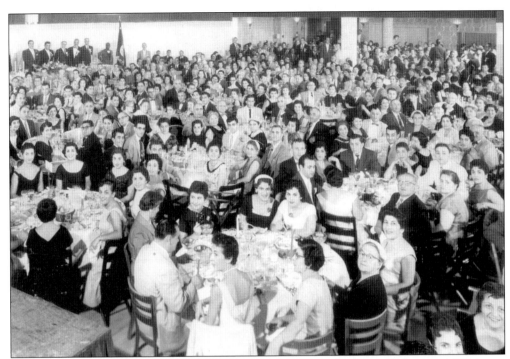

Pictured here is the 23rd Annual Convention of the Assyrian American Federation of Chicago, which was held from August 31 to September 2, 1956.

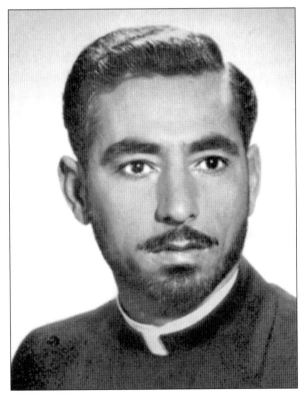

This is Rev. Aprim Elias de Baz (of Baz). He came to Chicago in 1961. Originally from Jezira, Syria, he was the sixth priest of the priest's family of the Baz district. He received his religious education at the Theological Seminary of the Church of the East at Khabur, Syria, which was founded by His Holiness Mar Eshai Shimun. Rev. Aprim was ordained a deacon in 1956, by Mar Joseph Khanisho, Metropolitan of Iraq, in Khabur, Syria, and served two years in the Villages of Tel Roman (upper), Tel Baz, and Tel Jezira. In 1958, he was ordained a priest in Baghdad, by Mar Esho Sargis, Bishop of Jeloo. He was appointed by Mar Eshai Shimun to serve at Mar Sargis Church.

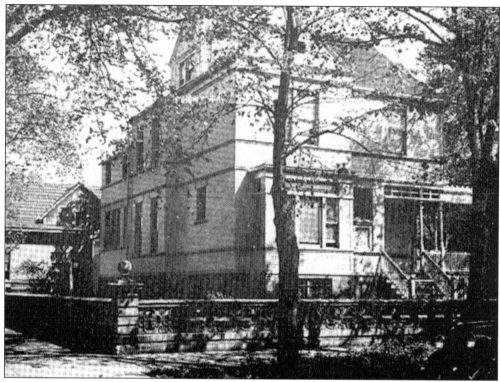

Pictured here is St. Ephrem's Chaldean Parish, located at 1054 West Oakdale Avenue in Chicago, *c*. 1960.

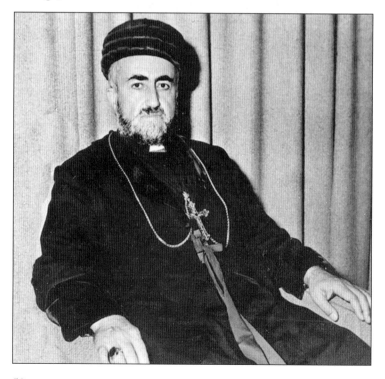

Pictured above is Mar Eshai Shimun, Catholicos Patriarch of the Church of the East, *c*. 1962.

Pictured above is Rev. Bidawid's congregation. In July 1962, Rev. Thomas M. Bidawid, pastor of St. Ephrem's Church, broke ground for the new church located at Maplewood and Bryn Mawr Avenues in Chicago. Father Bidawid is accompanied by his assistant, Rev. Sada S. Yonan, pictured to the right of Father Bidawid.

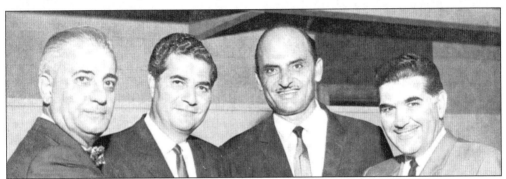

Assyrian activists and leaders of the 1960s are pictured here. From left to right are: Malcolm Karam, editor of the *Assyrian Star* magazine (published in Chicago since 1972); John Abraham, elected Vice-President of the Assyrian American Federation in 1966; the Honorable William Ibrahimi, the Assyrian Representative in the Iranian Majlis; and Lincoln Tamraz, the President of the Assyrian American Federation of 1966.

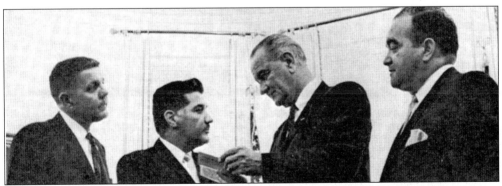

President Lyndon B. Johnson accepted a Life Membership into the AMVETS on July 21, from the AMVETS National Commander, Lincoln S. Tamraz. He presented the president with a special Silver Helmet award on May 19, 1964. Lincoln Tamraz served in the United States Army during World War II, and he was employed by the Department of Revenue, State of Illinois.

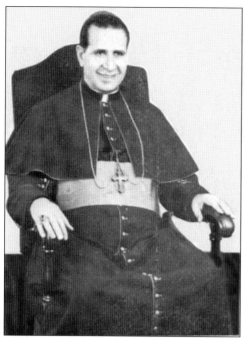

Former priest, Bishop Thomas Bidawid is pictured here. He came to Chicago in 1952. He was ordained a priest in Mosul, Iraq, in 1935. In 1966, Rev. Thomas M. Bidawid, pastor of St. Ephrem's Church, was appointed Archbishop and named to head the new Archepiscopal See of Ahwaz, Khorramshahr, and Abadan, Iran.

Pictured here is Dr. George M. Lamsa of Mar Bisho (Turkey), renowned scholar of Theology, Aramaic Peshitta Bible translator, lecturer, and author. He came to America in 1916, and studied at the Episcopal Theological Seminary in Alexandria, Virginia, and at Dropsie College in Philadelphia. He was field secretary to the Archbishop of Canterbury's Assyrian Mission in America. He was the founder of the Aramaic Bible Society in 1943. Dr. Lamsa was an honorary member of conventions of the ANA held in Chicago.

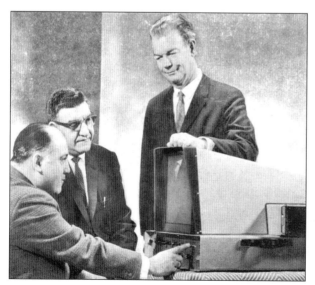

Pictured here, from left to right, are: Ray Shlemon, *Chicago Tribune* staff artist and inventor of the MIMIC; Paul Newey, attorney; and Joseph I. Woods, chief investigator for the Better Government Association. In 1957, Paul Newey (son of Rev. Paul Sarkhosh Newey) was offered a position as an investigator for the Cook County State's Attorney, Ben Adamowski. They were the main investigators of city scandals and corruption in the 1950s and '60s.

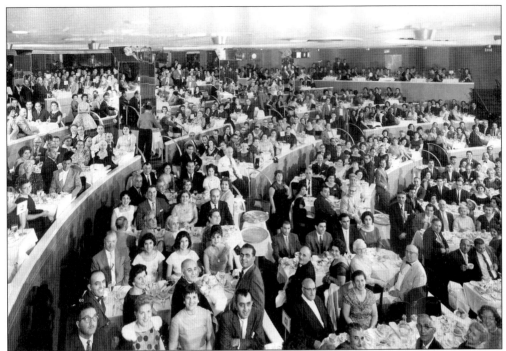

This is a photo of the 27th Annual Convention of the Assyrian American Federation, held at the Morrison Hotel in Chicago, c. 1960.

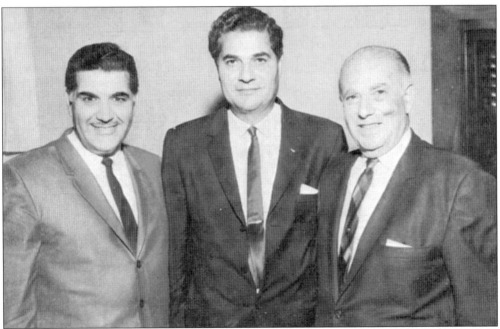

Pictured here are the leaders of the 33rd Annual Convention of the Assyrian American Federation, which was held September 1–5, 1966, in Chicago. From left to right are: Lincoln Tamraz, newly-elected president of the federation; John Abraham, newly-elected executive vice president; and Gabriel Sargis Sr., Honorary Convention Chairman for 1966.

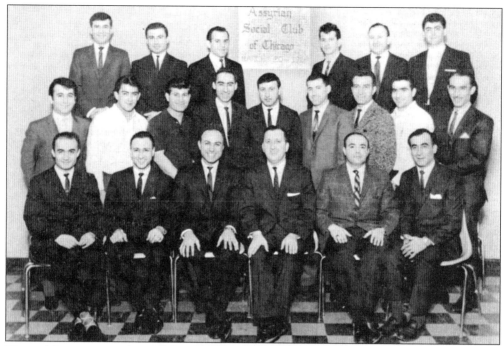

Pictured here are members of the Assyrian Social Club of Chicago, which was founded on January 10, 1965.

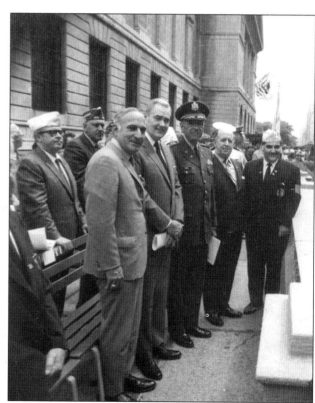

Shown here is the 92nd Memorial Day Parade on Michigan Avenue in Chicago, c. May 30, 1970. From left to right are: Sen. John Nimrod; George Dunne, President of Cook County Board; Lt. Gen. Vernon P. Mock; Maj. Gen. Francis Kane; and Lincoln Tamraz, National Commander.

Two

A FAMILY HISTORY

"My native land is, or was, Persia. I was born in the town of Urmia in 1910, which was later renamed Rezayeh in honor of Mohammed Reza Shah Pahlavi, Shah of Iran.

I was five years old in the spring of 1915, during the First World War, when the Turks and Russians reoccupied Urmia. The Turks wanted the Assyrians to join them to fight against the Russians. The Russians made similar gestures to persuade them to fight against the Turks. Some Assyrians decided not to fight anyone. . . . Five thousand five hundred more Assyrians escaped Urmia during 1917. This was a crucial year for all Assyrian Christians in all of Iran.

My brave mother gathered rice, flour, and a tea kettle and clothes, and scattered them on our one donkey. I was seven years old and can't remember all she saddled on this beast of burden. Our family that made and survived this journey included me—age seven, my brother Joseph—age 14, my sister Susan—age nine, and my mother—about 37 years old. My father was in America working as a cabinet maker in Chicago. Persia was poverty-stricken, and no way could a family be supported without some outside employment to help financially—not only the immediate family but also many relatives.

Our donkey was truly a beast of burden. He not only carried all provisions in the saddle bags, but me too, as I was the youngest and rode the animal when I was tired. My sister Sue said I was always tired, so she was never allowed to ride the donkey. Mother had also salvaged a couple of precious belongings—namely a silver wedding belt and a pair of gold earrings, which my sister and I inherited. The 5,500 Assyrians departed from Urmia quickly and quietly so we could get an early start before the Moslems found out what was planned. Many older people decided not to chance it, so they remained in the hope that some of their Moslem neighbors of many years would protect them. Most of them were slaughtered, and the towns were burned to the ground.

Our trip was treacherous and long. We rested by day and traveled by night so the enemy could not reach us. While we were making moves to reach America, others who were not as fortunate as us has to make decisions as to where to go. It must have been the month of June when we arrived in New York, because I remember still wearing my blue serge suit, and it was hot. Mother had bought me a darling straw hat with little flowers all around like a band. I was a real immigrant, with a blue serge suit and a flowered straw hat. My sister was a little better prepared, as she had her pongee silk two-piece dress, and she looked lovely and cool. Mother always looked just right no matter what she wore. I guess at age 11, one's mother is the most important person in one's life." (Excerpt from *My Story* by N.J. Schwarten, Chicago, 1998.)

The Nimrod family, Anna and Joseph of Seeri Village, Iran, moved to America with their children Helen, Susan, and Joseph, at the beginning of the twentieth century. After some years of traveling through Iraq, Russia, Manchuria, India, and Italy, they settled in Chicago. When they reached America, another son, John, was born.

Their father had found a furnished apartment for them on West Ontario Street in Chicago, where many other Assyrian families had lived. Most of them were members of the Fourth Presbyterian Church. Helen went to school in Chicago, and after her graduation from Waller High School, she worked at a bank for a few years. She was 20 years old when she married Jeremiah Sargis James. She met him at the Carter Memorial Assyrian Church. At the time of their marriage, Jerry was starting as a painting contractor, and in a few years, the business had grown to be the largest in the city in the Depression years, employing some 240 painters—over half of which were Assyrians. He made a name for himself as a residential developer, pioneering and building successful high-rises along Sheridan Road in the Edgewater neighborhood of Chicago. Helen and Jeremiah were blessed with two sons, Kenneth and Edward, who came into the family business after graduating from college and law school. The sons took over their father's business after his death in 1958. They established James Companies and became the most famous and successful land developers in Chicago and its suburbs.

Helen served for over 45 years on the Board of the Presbyterian Homes in Evanston. She also served as the member of the Board of the McCormick Theological Seminary. In the 1970s, she became a member of the Assyrian Universal Alliance Foundation and then became the president of the first Assyrian Service Agency to be open daily and staffed to serve the Assyrian community of Chicago. She initiated a program to teach the Assyrian and English languages. In 1988, she helped Assyrian students to establish the Ashurbanipal Library, which later became part of the Foundation. Today it is the largest Assyrian research and reference library in the world. For over 16 years, Helen has awarded scholarships to over 1,000 Assyrian students, amounting to over $1 million. In 1990, she founded the Assyrian Heritage Museum at the

AUAF. She was honored by the Assyrians as a "Woman of the Century" in 1999. She has also established an Assyrian lecture series at Northwestern University.

Helen Schwarten passed away one year ago. Two months before, she made a major donation to the Assyrian School and Center of Duhuk, North of Iraq. She had many plans and ideas, including a new building for the museum and library. Helen was a real philanthropist and a very dedicated person.

Born in the Lakeview district of Chicago and a first-generation Assyrian, John was the youngest son of Anna and Joseph Nimrod. From the beginning, he was a very active and talented member of the Assyrian community. He was educated in the Chicago Public Schools, the University of Illinois, the Illinois Institute of Technology, and Northwestern University, where he received a B.S. degree in mechanical and industrial engineering in 1950. He was a combat veteran of both World War II and the Korean War, and spent a total of six years in service in Europe and the Far East. He graduated first in his class in officer candidate school at Fort Benning, Georgia. John received six Battle Stars, the Bronze Star, and the Wahrung the Korean Medal. He was honorably discharged with the rank of captain in 1952.

John served two terms as the state senator in the Fourth Legislative District and three terms as Republican Township Committeeman. He was assistant to the chairman of the Illinois Industrial Commission, assistant director of the Illinois Department of Revenue, assistant to the president of the Cook County Board of Commissioners, and past president of the Township Officials of Cook County. From 1992, he was a member of the Unrepresented Nations and People Organization (UNPO), the organization that was founded to give voice to those nations and peoples such as the Assyrians. He was elected UNPO vice chairman. In February 2001, in Tallinn, Estonia, he was elected as the chairperson of its general assembly. In 1994, Senator John Nimrod was elected secretary general of the Assyrian Universal Alliance.

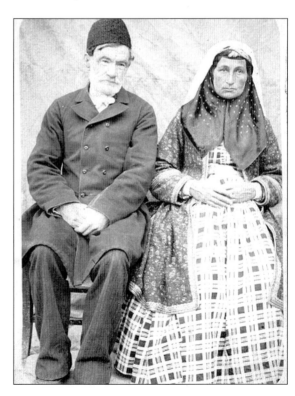

Pictured here are Nimrod and Martha, Helen and John's grandparents in Iran.

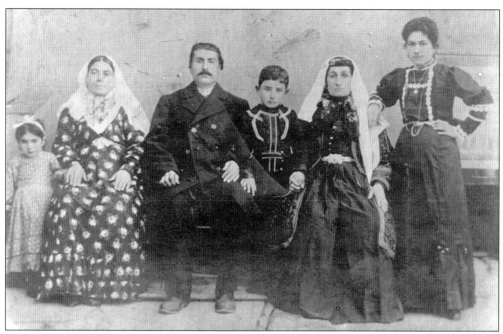

Pictured above is the Joseph Nimrod family in Urmia, *c.* 1910. From left to right are: Susan (daughter), Anna Kochaly (wife), Joseph Nimrod, Joseph (son), Martha (Joseph Nimrod's mother), and Katrina Arsanus (Joseph Nimrod's sister and the wife of Benjamin Arsanis).

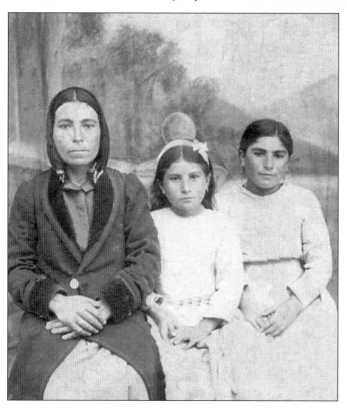

This photograph was taken in Baghdad in 1920. Pictured from left to right are: Anna Kochaly Nimrod, Helen, and Susan.

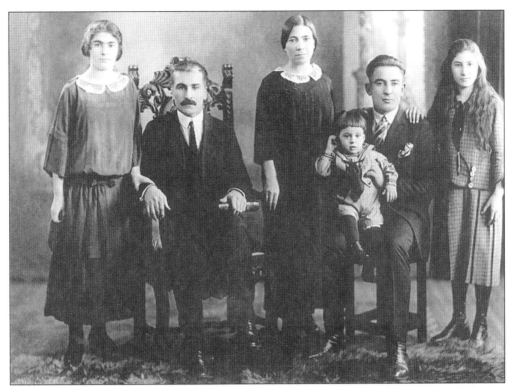

Pictured here is the Nimrod family in Chicago, c. 1924. From left to right are: Susan (15 years old), Joseph Nimrod, Anna, Joseph (17 years old), John (2 years old), and Helen (13 years old).

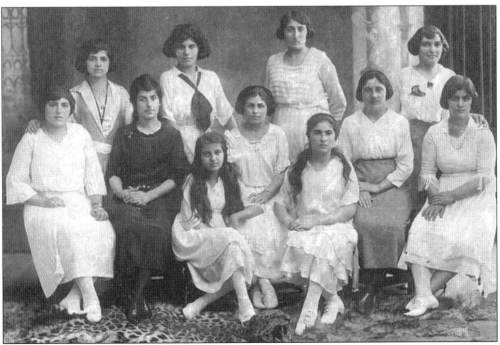

Pictured here is a group from Carter Memorial Church, c. 1921. Seated fifth from the left is Helen.

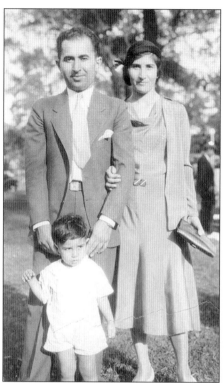

This is Jeremiah and Helen with their son, Kenneth. This photograph was taken at Lincoln Park in January 1931.

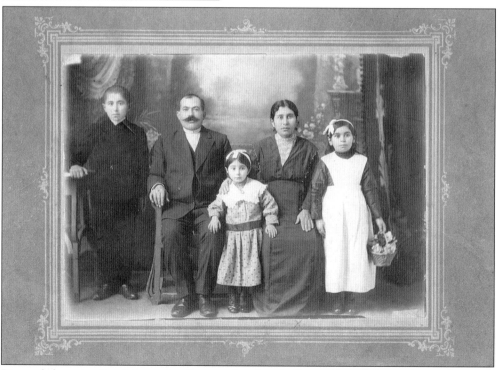

Pictured above is a Sargis James family portrait, taken in Russia. From left to right are: Jeremiah Sargis James, Julia (daughter), Sargis' wife (name unknown), and Susie (daughter).

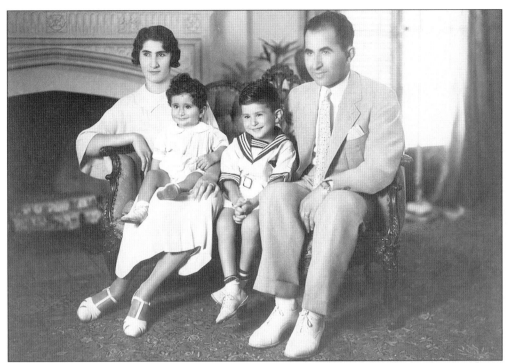

Jeremiah and Helen are pictured with their children Edward (left) and Kenneth (right) in 1933.

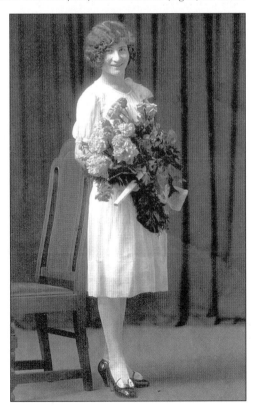

Helen is pictured here at her graduation from Waller High School in the 1930s.

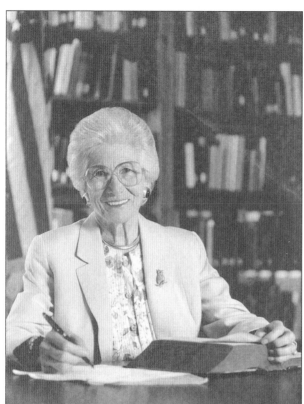

Helen Schwarten, President of the Assyrian Universal Alliance Foundation, is pictured at the Ashurbanipal Library in 1998.

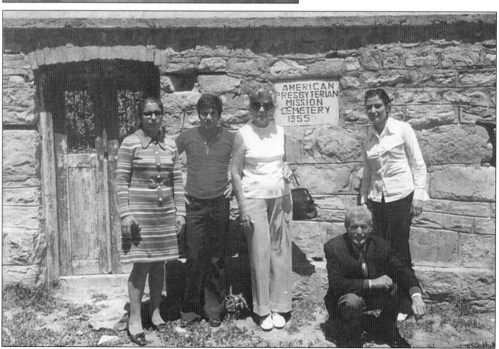

This photograph was taken at the American Presbyterian Missionary Cemetery in Seeri Village, Iran, many years after Helen left her place of birth.

Joseph Nimrod is pictured with his son John in Lincoln Park in 1929.

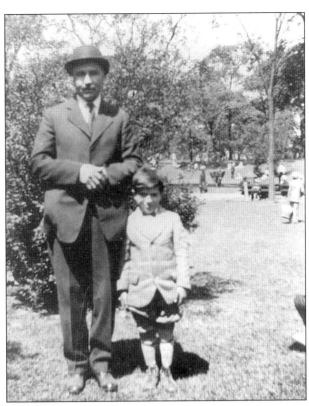

This photograph was taken in the 1930s at the Carter Memorial Church at 54 West Huron Street. From left to right are: Albert (last name unknown), Edward E. Joseph, Kambusus Yonan, and John J. Nimrod.

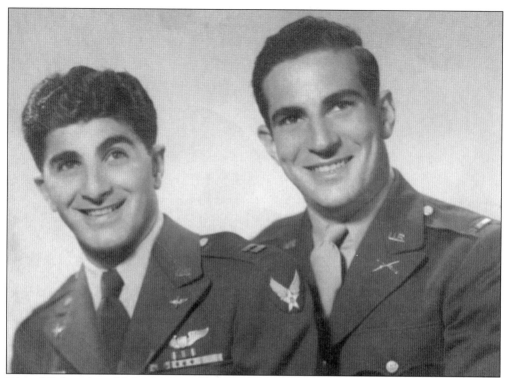

Edward E. Joseph and John J. Nimrod are pictured here in 1943.

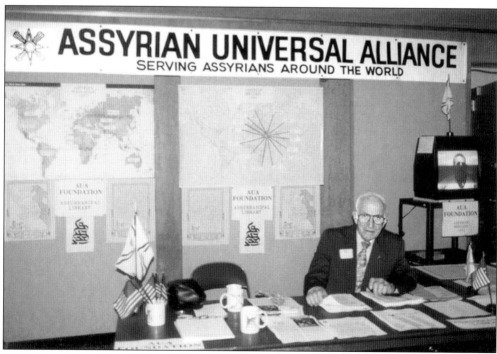

John Nimrod was elected General Secretary of the Assyrian Universal Alliance in Modesto, California, in 1994.

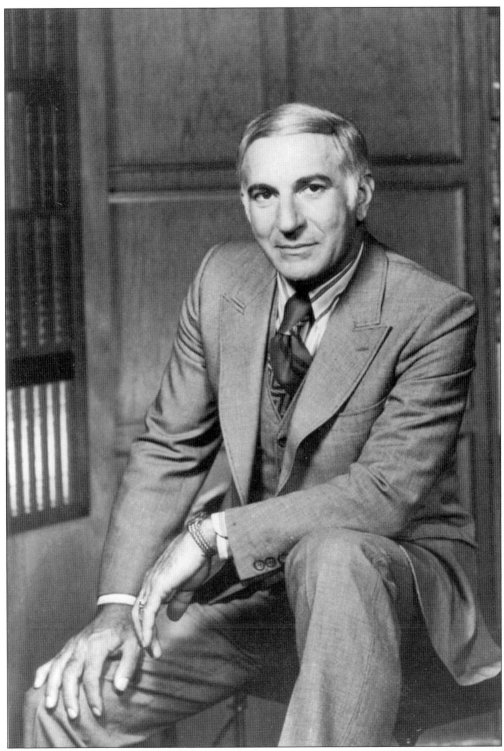

John J. Nimrod, State Senator of the Fourth District, is pictured at 940 Woodland Drive in Glenview, Illinois.

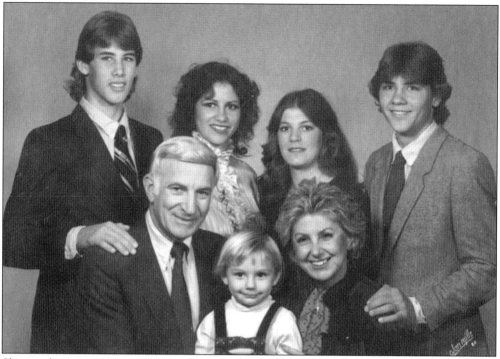

Shown above is Senator John J. Nimrod's family. From left to right are: (bottom) Senator Nimrod, John Paul (grandson), Inga (wife); (back) John II (son), Naomi (daughter), Elizabeth (daughter and mother of John Paul), and Joseph (son).

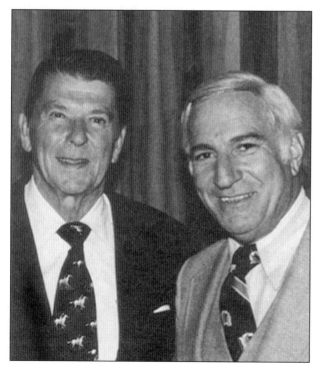

Senator John Nimrod and President Ronald Reagan are pictured in Washington, D.C. on March 16, 1982.

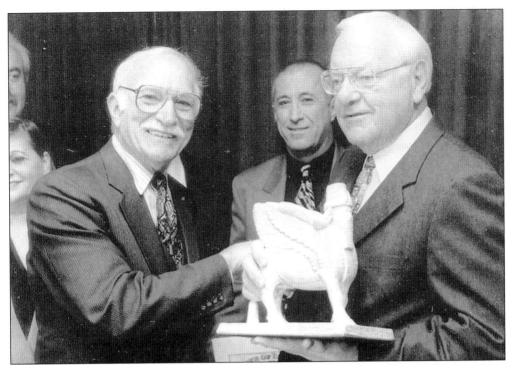

Senator John J. Nimrod presented an Assyrian souvenir to Governor George H. Ryan.

These are the directors of the James Companies. Edward R. James, Principal and Chairman of James Building Corporation (BA, Michigan State University) is at left, and Kenneth J. James, Chairman of James Investment Company (BA, Stanford University and JD, Northwestern University) is at right.

This is a Christmas party organized by Helen Schwarten at the AUAF in 1990.

AUA leaders are pictured here with the President of the Republic of Georgia, Edward Sheverdnadze. From left to right are: President Sheverdnadze, Senator John Nimrod, and Luther Alkhaseh, President of the Chamber of Commerce of California.

John's birthday was celebrated this particular year at Reza Restaurant. From left to right are: (standing) Helen Schwarten and John Nimrod; (seated) Warren James, Jerry (Jeremiah) James, and Edward James.

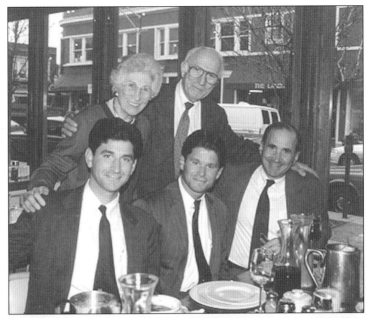

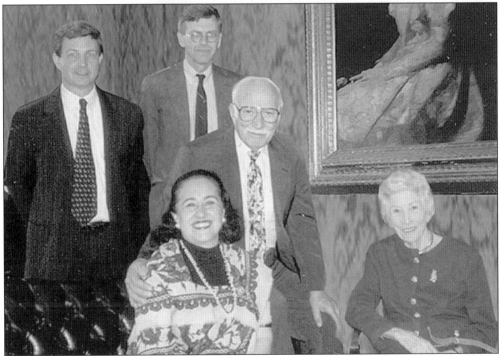

For many years, the Assyrians of Chicago—especially the AUAF—have had good relations with Harvard University and its scholars. From left to right here are: Michael E. Hopper, Head of the Middle Eastern Division; Prof. J.F. Coakley, Department of Near Eastern Languages and Civilization; (bottom) Dr. Eden Naby, historian, chair of the Board of Trustees of the David B. Perley Memorial Assyrian Fund, and co-author with M. Hopper of *The Assyrian Experience: Sources for the Study of the 19th and 20th Centuries* and other publications, Senator John J. Nimrod, and Helen Schwarten, at Harvard University in 1998.

Pictured here is the AUAF Scholarship Dinner, sponsored by Helen Schwarten in the 1990s.

Pictured here are John J. Nimrod, Helen Schwarten, Patriarch Mar Dinkha IV, Homer Ashurian, and Hidoo Hidoo, at the AUAF office.

Three

ASSYRIANS TODAY

From the 1970s to the 1990s, many Assyrians immigrated to Chicago from Iraq, Iran, Syria, Lebanon, and Turkey. Thousands of them flowed there after the Iran-Iraq and the Gulf Wars. Today, Assyrians live all over Chicago. The main population is concentrated in Rogers Park, Albany Park, Skokie, Lincolnwood, Morton Grove, and Des Plaines.

There are more than 20 Assyrian organizations and churches in the Chicago area. Among them are the Assyrian American Association of Chicago, established in 1917; the Assyrian Universal Alliance Foundation; the Assyrian National Council of Illinois; the Assyrian American Civic Club of Chicago; the Assyrian Social Club; the Assyrian Academic Society; the Mar Zaya Assyrian Organization; and many others.

In the early 1970s, the Assyrian Universal Alliance Foundation was founded to serve Assyrian immigrants. It became a center of aid efforts for the Assyrians. It has helped Assyrian students to obtain scholarships for many years.The Ashurbanipal Library was founded by a student group in 1986. Also existing are the Assyrian Heritage Museum at the AUFAF and the Mesopotamian Museum of Chicago of Dr. Norman Solhkhah, located at 6301–07 North Pulaski. There are also several Assyrian radio programs, including: "Assyrian Night Star," "Voice of Urmia," and "Voice of AUA," "Voice of Freedom." The several Assyrian publications include: *Journal of the Assyrian Academic Society, Assyrian Academic Studies, The Assyrian Sentinel,* and *Voice of the East.* Starting in the 1990s, the *Assyrian Business and Professional International Directory* was published in Chicago.

More than 10 churches represent the Assyrian denomination, including: Assyrian Church of the East (Mar Gewargis Church, Mar Sargis Church, and Mar Odisho Church), Carter Westminster Presbyterian, Assyrian Evangelical Covenant Church, Assyrian Pentecostal Church, and Assyrian Catholic Church.

There are two bookstores in the city: Al-Itekal Bookstore and AUAF Bookshop.

Assyrians own all types of businesses. The most popular type of business are construction contractors, beauty salons, auto repair shops, printing, insurance companies, real estate, restaurants, and all kind of medical offices.

Assyrians have a large percentage of young students. They study at Northwestern University, Loyola University, North Park University, University of Chicago, and others. Assyrians have several schools and classes of teaching the Assyrian language. Some of them are located at Mar Giwargis Church, Roald Amundsen High School, and North Park University.

Assyrians are Christians, and they celebrate Christian holidays, like Christmas and Easter.

In 1989, Assyrians of Chicago started to celebrate non-Christian Assyrian New Year on April 1 with a festive parade. All Assyrian organizations and representatives from the church

are present at the parade. Also they celebrate another popular pre-Christian holiday—Nusardi, which symbolizes the baptismal water rite at autumn time (July). Every August Assyrians commemorate Assyrian Martyrs Day in honor of those who were massacred in Turkey, Iran, Iraq, and Russia (Stalinism).

On June 14, 1992, with the cooperation of the City of Chicago, Assyrians honored Assyrian King Sargon II with a street name. This idea was proposed to the city council by Hanny Baba, a restaurant owner. "King Sargon Boulevard" encompasses the stretch of Western Avenue from Peterson to Devon. During the dedication ceremony, thousands of Assyrian Americans waved national flags, played patriotic music, and cheered speeches.

In 1992, John Hosanna and his friends from the Assyrian-American Amvet Post 5 began to collect money to raise a monument in honor of Assyrian-Americans soldiers who gave their lives and to those who served in World War II, the Korean War, Vietnam, and the Gulf Wars. Later they decided that it would be placed at Elmwood Cemetery. Hosanna died in 1997, but his idea was kept alive. Lincoln S. Tamraz, Marshal Joseph, Lincoln Peters, Edward E. Joseph, Cyrus Alexander, Albert Miglioratti, Senator John Nimrod, and many others worked on to finish the great task. "We want people to see this. In 20 years we'll be gone, but our monument, our pride will be here," they said. The dedication took place on May 16, 1998, at the Elmwood Cemetery in River Grove, Illinois. Governor Jim Edgar sent this message with his best wishes on that special occasion,

"The spirit of the Assyrian people is with creativity, resourcefulness, and love of God, family, and country. I commend the Assyrian-American community for their patriotism and loyalty. You should be proud of the many contributions Assyrian Americans have made to the state of Illinois."

Left: This is a reproduction of the cover of the *Voice of the East* magazine. In 1981, it was founded by His Holiness Khanania Dinkha IV, Patriarch of the Apostolic Catholic Assyrian Church of the East in Tehran, Iran. In 1982, it was started in Chicago and edited by Ekhitar B. Moshi. Since 1994, it has been edited by Rev. Shleemon P. Hesequil.

Below: This is the Mart Maryam Church in Roselle, Illinois.

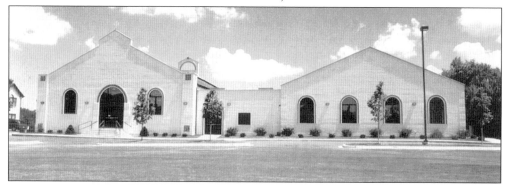

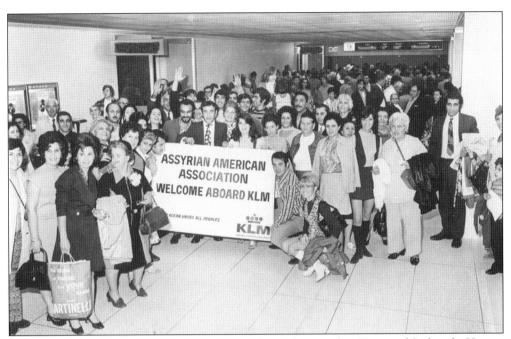

This is Malcolm Karam, chemical engineer and son of Dr. Luther Karam of Satluweh. He was president of the Assyrian American Federation in 1958, and editor of the *Assyrian Star* magazine from 1968 to 1972. He was honored as the Assryian Man of the Year in 1969.

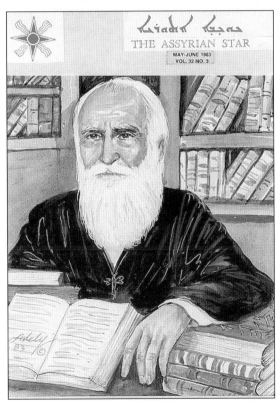

This is a reproduction of the cover of the *Assyrian Star* magazine, published since 1952.

Pictured here is the famous Assyrian author, poet, teacher, journalist, and editor of the *Voice of the Assyrians*, Gewargis Benjamin of Ashita, Iraq. He moved to Chicago in 1975, and published many books at Neneveh Press in Chicago.

"VOICE OF ASSYRIANS"
Monthly General Newspaper
3247 WEST BRYN MAWR
CHICAGO, ILLINOIS 60659
Telephone: (1-312) 478-9000

Editor-in-Chief
KLAMES M. GANJI

PUBLISHING COMMITTEE

G.S. BENJAMIN Assyrian
MINAS GORGIUS Arabic

SUBSCRIPTION PER ANNUM

$20.00 U.S.A. and Canada
$30.00 (Airmail) Overseas
$35.00 Embassies and Officials

UOICE OF ASSYRIANS

ܩܠܐ ܕܐܬܘܪ̈ܝܐ

صوت الآشوريين

GENERAL NEWSPAPER

| VOLUME 13 | JUNE 1984 | NUMBER 2 & 3 |

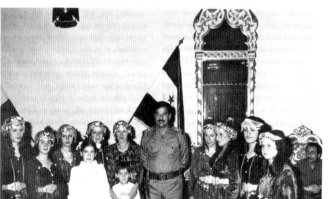

ܣܘܪܓܕܐ

This is a reproduction of the cover of the *Voice of Assyrians*, published in Chicago since 1974.

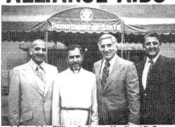

This is a reproduction of the cover of *The Assyrian Sentinel*, political organ of the AUA, published in 1976.

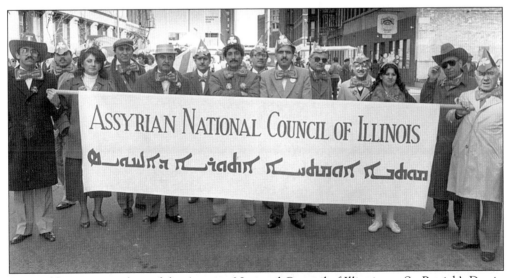

Pictured here are members of the Assyrian National Council of Illinois, on St. Patrick's Day in 1987.

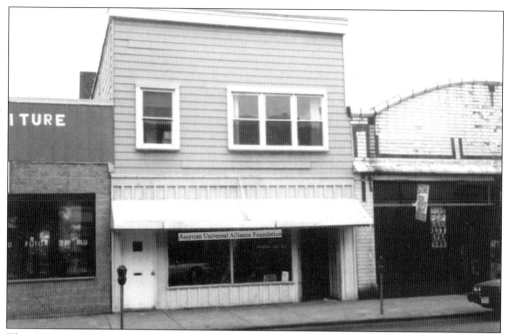

The Assyrian Universal Alliance Foundation (AUAF) is located at 7055 North Clark Street. In the early 1970s, the AUAF was founded to serve Assyrian immigrants. It has since become a center of aid efforts for the Assyrians.

This is a reproduction of the cover of the first Assyrian historical videotape called *Phases of Civilization: Assyrian Legacy*, starring George Kennedy and issued in 1989.

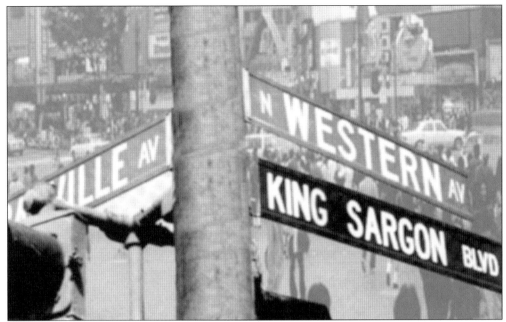

The Assyrian community and the City of Chicago honored Assyrian King Sargon II with a street name. The two blocks of Western Avenue just south of Devon were blocked off on Sunday, June 14, 1992, for a dedication ceremony. Thousands of Assyrian Americans waved national flags, played patriotic music and hymns, and cheered speeches. King Sargon Boulevard encompasses the stretch of Western Avenue from Peterson to Devon.

Pictured here, from left to right, are: Dr. Khoshaba P. Jasim, poet, journalist, and editor of the *Assyrian Star* magazine (1977–78); Sarah Sayad Paz, writer and publicist; and Edward Hasso, producer of the *Assyrians Around the World* program on Channel 25.

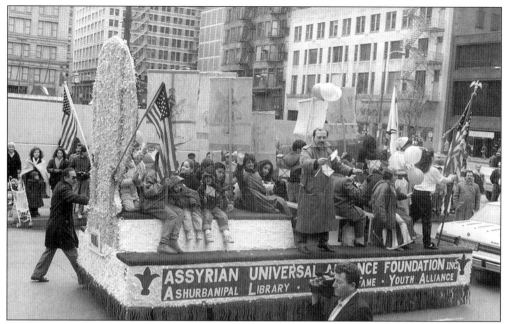

In 1989, Assyrians of Chicago began to celebrate Assyrian New Year with a festive parade.

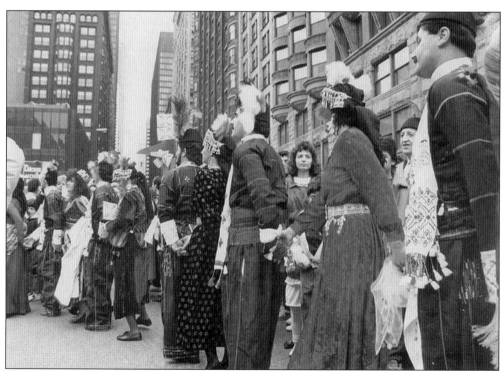

Pictured here is the traditional Assyrian dance called Shaikhaneh, performed at the Assyrian New Year Parade. (Photograph by Edison Hasso.)

Here is a photo of Yalda Hajey in traditional national costume of mountain Assyrian of Tyare.

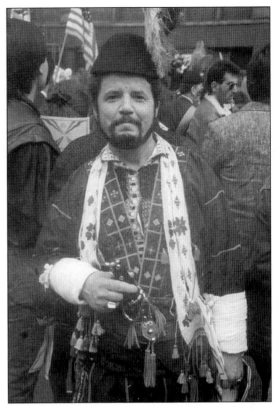

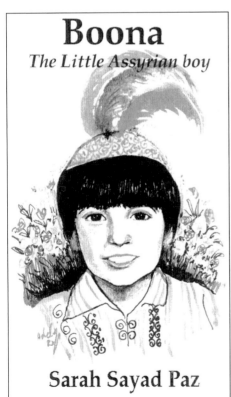

Boona
The Little Assyrian boy

Sarah Sayad Paz

This is a reproduction of the cover of *Boona, the Little Assyrian Boy*, published in 1991, at the Ashurbanipal Library at the AUAF. This book is a description of Assyrian life after World War I, through the eyes of Boona.

Veterans hope to set memories in marble

Assyrian Americans raise cash for monument

By Daniel Borsky
TRIBUNE STAFF WRITER

City watch
People

John Hosanna, an 85-year-old World War II veteran, has a magnificent dream. It may well be the very last dream he can make come true.

For the past two years, Hosanna has been struggling to collect enough money to raise a monument in honor of Assyrian Americans in Chicago who, like himself, served in the U.S. armed forces during World War II and the Korean and Vietnam Wars.

To raise money, Hosanna last year put together and published a booklet devoted to Assyrian American veterans.

"We are raising the fund since we published this book," said Hosanna, a Morton Grove resident.

Each book sold adds $10 to the pool, but Hosanna must rely mostly on donations from other veterans or Assyrians.

"One of our boys passed away and left us $5,000," Hosanna said. "Another lady passed away last week. Before she did, she drove to my house and gave me a check

survive.

Despite fighting on the Allies' side in both World Wars, the Assyrians repeatedly have been denied their wish to live in their own country again. Once a mighty and prosperous empire, the nation has been plummeting into oblivion ever since it lost its homeland. It can't be found on the world map today.

Perhaps that's why Assyrians today are commonly confused with Syrians or often called Kurds, after an area in southern Turkey and northern Iraq where many live.

In the U.S., when an Assyrian is asked where he or she is from, the answer may even be "Lebanon." That's because some Assyrians identify with the closest entity to be found on the map that has a similar religious background.

Like half of the Lebanese, Assyrians are Christians.

"The history of Assyrians began

Apparently, Hosanna also has preserved the defiance encoded in his pedigree. Although he needs a little help to climb the stairs or

he and Peters are forced to bargain over the grave sites at the cemetery. They intend to exchange graves in order to patch

another 250 who survived.

"With all probability, it will be a small monument," Peters said. In the end, it will depend on

John Hosanna, 85 and an Assyrian-American, wears his World War II uniform as he hopes for a monument that would list the names of 14 Assyrian-American servicemen killed in action and another 250 who survived.

In 1992, John Hosanna and his friends from the Assyrian American AMVET Post 5 began to collect money to erect a monument in honor of Assyrian-American soldiers who gave their lives and to those who served in World War II, the Korean War, Vietnam, and the Gulf War. Shown above is a reproduction of the article, "Veterans Hope to Set Memories in Marble," from the *Chicago Tribune* on Monday, July 29, 1996.

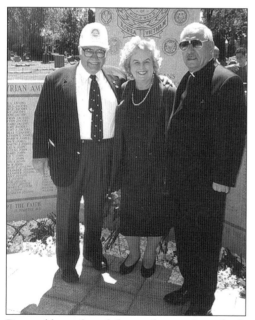

Pictured here, from left to right, are: Lincoln S. Tamraz, Commander of AMVET Post 5; Pat Michalski, Assistant to the Governor for Ethnic Affairs; and Archdeacon Rev. Aprim De'Baz.

Last chance for immortality

World War II veterans from Chicago's rapidly assimilating Assyrian-American community build a monument to their 500 colleagues in hopes of keeping their story alive.

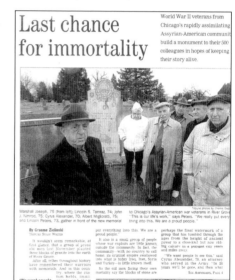

Marshall Joseph, 76 (from left); Lincoln S. Tamraz, 74; John J. Nimrod, 75; Cyrus Alexander, 70; Albert Miglioratti, 75; and Lincoln Peters, 73, gather in front of the new memorial

to Chicago's Assyrian-American war veterans in River Grove. "This is our life's work," says Peters. "We really put every thing into this. We are a proud people."

By Graeme Zielinski
TRIBUNE STAFF WRITER

It wouldn't seem remarkable, at first glance, that a group of proud old men last November placed three blocks of granite into the earth of River Grove.

After all, tribes throughout history have remembered their warriors with memorials. And in this country, where the custom holds, immigrants and their descendants have honored the sons they offered up for their new home.

But quickly it becomes clear that there is something special about the humble exhibit in the near west suburb, the 16,000 pounds of granite that bear the names of 500 Assyrian-Americans from the Chicago region who as young men were sent to serve their country.

Just as the names are etched into the granite, the years are etched onto the lives of the men who have registered the remembrance.

"This is our life's work," said Lincoln Peters, 73, a retired draftsman whose right leg still bears the marks of the Japanese bullet that pierced it more than 50 years ago. "We really

'We want people to see this. In 20 years we'll be gone, and then what will there be?'
Cyrus Alexander, World War II vet

put everything into this. We are a proud people."

It also is a small group of people whose war exploits are little known outside the community. In fact, the community—with no country to call home, its original empire swallowed into what is today Iraq, Iran, Syria and Turkey—is little known itself.

So the old men facing their own mortality say the blocks of stone are

perhaps the final watermark of a group that has tumbled through the ages from the height of ancient power to a close-knit but now ebbing culture in a polyglot city years and miles away.

"We want people to see this," said Cyrus Alexander, 70, an attorney who served in the Army. "In 20 years we'll be gone, and then what

See ASSYRIANS, Page 4

See ASSYRIANS, Page 4

ASSYRIAN AMERICANS WHO GAVE THEIR LIVES SERVING OUR COUNTRY

"We've broke our hearts on this," Joseph says of the memorial. Tamraz points to names on the memorial of friends who died in the line of duty.

This is a reproduction of the article "Last Chance for Immortality," from the *Chicago Tribune* on Sunday, April 29, 1998.

88

The student founders of the Ashurbanipal Library are pictured with His Beatitude Mar Gewargis Sliwa, of the Assyrian Church of the East in Iraq. Pictured from left to right are: Dr. Maureen Lazar, Robert DeKelaita, His Beatitude Mar Gewargis, Peter Bet Basso, David Malick, Raymond David, Raymond Melko, and kneeling is Sargis Sangari.

Pictured here is the Honorable Homer Ashurian. He was born in Charbash Village Urmia in 1936. After completing his high school education, he studied at the University of Tehran and received his BA in Archaeology and his MA in Assyriology. He then worked in the Ministry of Culture as a curator and head of the Iranian Cultural Museum. In 1963, he became the principal of the Arian High School in Tehran. In 1976, he was elected congressman to represent the Assyrian people in the Iranian Parliament. He came to the United States in 1984, after the revolution, and has been working with the AUAF as a head of the Ashurbinapal Library. He now runs historical and cultural research and is working on the Assyrian Project on Oral History. He is also the editor for the Aramaic Bible Translation, the organization that is translating the Bible from Syriac into modern Assyrian. This photograph was taken at the library opening in 1988, and Ashurian is giving his address, "The First Library in the World."

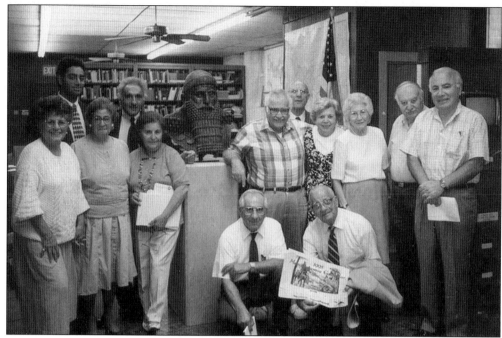

Board members of the AUAF are pictured here on September 13, 1995. From left to right are: Martha Merza, Rose Alexander, Josephine Muradzadeh, Lincoln Tamraz, Sari Georges, Helen Schwarten, Ninos Andrews, Norman Americus; (standing in back) Edwin Gania, Albert Nader, Homer Ashurian; (bottom) Hido Hidoo and Malcolm Karam.

His Holiness Mar Dinkha IV, Patriarch, visited the Ashurbinapal Library on October 16, 1997. He toured the part of the library devoted to the rare collection of manuscripts and periodicals. This photograph depicts the patriarch examining the old magazine *Kokhwa*, which was published in Urmia, Iran, since 1906.

This is a portion of the history exhibit at the Heritage Museum of the AUAF.

This is John Yonan, President of the Service Master Steel Corporation, located at 8324 North Lincoln Avenue in Skokie, Illinois. He was Chairman of the Assyrian Refugee Committee of AUA in 1976, and Ambassador of AUA in 1977. He represented Assyrians in Beirut, Lebanon, in a special meeting with President Elias Sarkis of Lebanon. They discussed the project of the rebuilding of Lebanon and the humanitarian needs of Assyrians living there. John Yonan was chosen as Assyrian Man of the Year in 1977 at the 44th Annual Assyrian American National Federation Convention in Chicago.

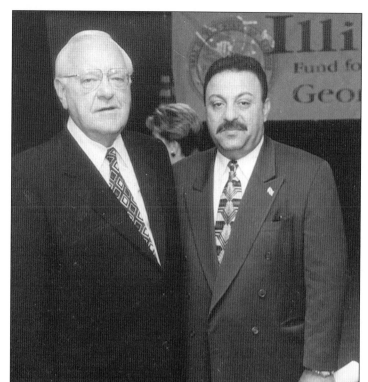

Pictured here are Governor George H. Ryan and Yousip Bet Rasho, producer of the daily radio program, "Assyrian Night Star," and president of the Assryian Chamber of Commerce.

The AUAF radio program is broadcast every Saturday on 1420 AM from 3:00 to 4:00 p.m. Pictured above are Hon. Homer Ashurian and Sen. John Nimrod.

Rev. John Booko, minister of the Baptist Church and author of *Assyria the Forgotten Nation in Prophecy* is pictured above, in the middle. With him are his wife, Burnell, and Hon. Homer Ashurian.

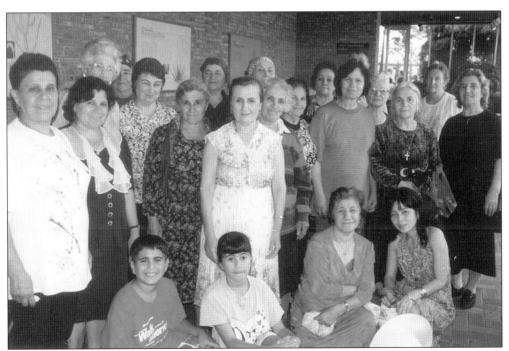

Pictured above are students of the English classes given at the Sunday School of the AUAF, run by Flora Benjamin.

Journal of

Assyrian
Academic
Studies

Vol. XV No. 1. 2001

Robert DeKelaita, Attorney at Law, founder of the Ashurbanipal Library, editor of *Nabu* magazine, painter, and history researcher is pictured here.

This is a reproduction of the cover of the *Journal of Assyrian Academic Studies* of 2001, edited by Dr. Robert Paulissian, M.D.; Daniel Benjamin; Youel A. Baba; Arian Ishaya, Ph.D; Edward Odisho, Ph.D; Francis Paz, Ph.D; Efrem Yildiz, Ph.D; Michael Abdalla, Ph.D; Francis Sargis, J.D.; and Sargon Hasso. The magazine was founded by the Assryian Academic Society in 1985.

Michael Mareewa is pictured at his Al-Itekal Assyrian bookstore at 3638 West Montrose. (Courtesy of His Beatitude Mar Gewargis, Metropolitan of Iraq, Assyrian Church of the East.)

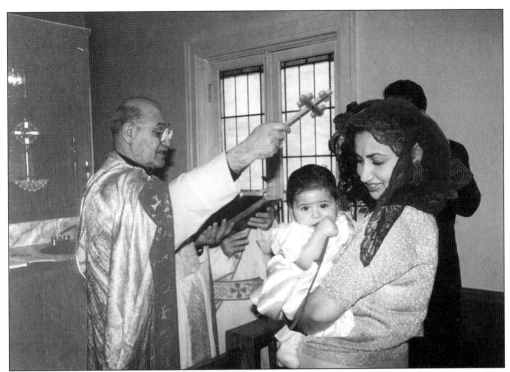

Rev. Shleemon P. Heseqial, of the Assyrian Church of the East and editor of the *Voice from the East* magazine, is pictured here performing a baptism at St. Georges Church.

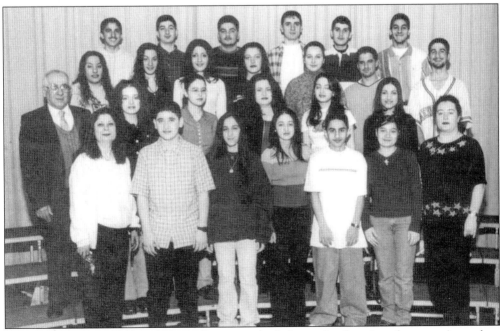

Rabi Hidoo Hidoo (left) and Emma Benjamin (right) run the Assyrian classes at Amundsen High School at 5110 North Damen Avenue.

Selected Bibliography

Assyrian American Association of Chicago, Inc. Celebrating its 80th Anniversary, 1917–1997, October 4th.

Assyrian Mothers' Cookbook. AUAF, 1995.

The Assyrian National Petition. New Jersey, 1946.

Assyrian Star, Vol. IV, #6, 1955; Vol. X, #1-2, 1961; Vol. VII, #1, 1958; Vol. XI, #5, 1966; Vol. XII, #3, 1967.

Coacley, J.F. *The Church of the East and the Church of England*. Clarendon Press: Oxford, 1992.

Daniel, Mooshie G. *Modern Persia*. Wheaton, IL, 1897.

Directory of Carter Memorial Assyrian Presbyterian Church of Chicago. 1907–1921.

Directory of Carter Memorial Assyrian-Persian Chapel of the Fourth Presbyterian Church of Chicago.

Elder, John. *History of the American Presbyterian Mission to Iran*. Literature Committee of the Church Council of Iran.

Malech, George D. *History of the Syrian Nation and the Old Evangelical-Apostolic Church of the East*. Minneapolis, 1910.

———, *Encyclopaedia Iranica*. Vol. 11. "Assyrians in Iran." London-New York, 1987.

Nweya, Polus (Paul Newey). *Kanone w-Shar'ate d' Gugtapa w-Swawuto*. Chicago, 1935.

Schwarten, Helen N.J. *My Story: Persia to America*. AUAF, Chicago, 1998.

Scroggs, Marilee M. *A Light in the City*. The Fourth Presbyterian Church of Chicago. Chicago, 1990.

Stein, M. A. Dissertation Submitted to the Faculty of the Graduate School of Social Service Administration in Candidacy for the Degree of Master of Arts. Chicago, 1922.

Stoddard, D.T. *Journal of the American Oriental Society Vol. 5*. "Grammar of the Modern Syriac Language as spoken in Oroomiah, Persia, and Koordistan." New York, 1856.

Thompson, Joseph P. *Memoir of Rev. David T. Stoddard*, Missionary to the Nestorians. New York, 1858.

Urshan, Andrew D. *The Story of My Life*. The Gospel Publishing House, St. Louis.

Wolk, Daniel. *Assyrians: Illinois Ethnic Coalition, A Guide to the Cultures and Traditions of Chicago's Diverse Communities*, forthcoming, October 1996.

———, *Preserving a Name in a Restless Land: The Assyrian Community in Chicago*. University of Chicago, 2000.

Yohannan, Abraham A. M. *Modern Syriac-English Dictionary*. Part 1. Columbia University: New York, 1900.